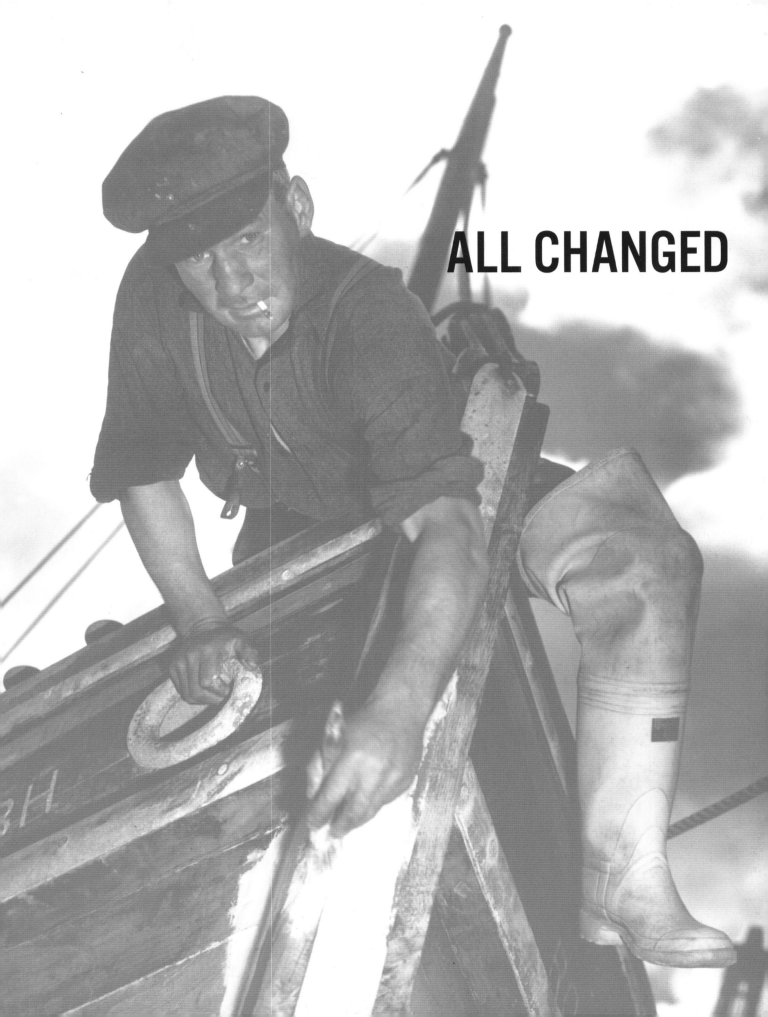

ALL CHANGED

Colman Doyle

is a prize-winning news photographer. He became a staff photographer in the *Irish Press* in 1951, and was also Ireland photographer for *Paris Match* for forty years. His awards include British Press Pictures of the Year, Four Masters, Kodak 'The World and Its People', PPAI Photographer of the Year, International Organisation of Journalists gold medal for News Photograph and many more. Throughout his career he has photographed world leaders, including John F. Kennedy, Charles de Gaulle, Richard Nixon and Margaret Thatcher.

John Quinn

from Ballivor, County Meath, has been a broadcaster with RTÉ for twenty-six years. He has presented and produced 'The Open Mind' since 1989, among many other programmes, including award-winning documentaries. He has published a number of books, including four books for children, one of which, *The Summer of Lily and Esme*, won the Bisto Book of the Year Award in 1992. He now lives in Galway.

Colman Doyle text by John Quinn

ALL CHANGED

FIFTY YEARS OF PHOTOGRAPHING IRELAND

THE O'BRIEN PRESS
DUBLIN

First published 2004 by The O'Brien Press Ltd,
20 Victoria Road, Dublin 6, Ireland.
Tel: +353 1 4923333; Fax: +353 1 4922777
E-mail: books@obrien.ie
Website: www.obrien.ie
ISBN: 0-86278-873-0
British Library Cataloguing-in-Publication Data
Doyle, Colman
All changed : fifty years of photographing Ireland
1.Ireland – Pictorial works 2.Ireland – History – 1922– – Pictorial works
3.Ireland – Social life and customs – 20th century – Pictorial works
I.Title II.Quinn, John, 1941–
941.5'00222

1 2 3 4 5 6 7 8 9 10
04 05 06 07 08 09

Typesetting, editing, layout and design: The O'Brien Press Ltd
All photographs, including cover images: Colman Doyle
Printing: Eurolitho SpA, Milan (Italy)

Contents

Dedication/Acknowledgements

DEDICATION

For my grandchildren — Sarah, David, Emer and Rory

ACKNOWLEDGEMENTS

I am especially grateful to Seán Óg Ó Ceallacháin, Martin Breheny, Billy Rackard and Peter McDermott for their help with the GAA photographs. Also to Martin Burke of the Olympic Council of Ireland, Mandy Piggett of the IRFU, Pat Costello of the FAI and Fergal McGill of the GAA for their help with research.

I would particularly like to thank Tim Pat Coogan for writing the foreword. Others to whom I owe gratitude are Eric Luke, Dermot O'Shea, Nigel Byrne, Mark Masterson, Brenda Fitzsimons, Benny Mone, Loreto McNamara, Ruth Rogers, Michael Gill of Aran. A special recognition for the O'Brien Press team for their professional attitude when selecting the photographs for my book: Michael O'Brien, Íde Ní Laoghaire, editor Eoin O'Brien and designer Emma Byrne, and Ivan O'Brien. Michael exercised a stern vigilance.
Colman Doyle

DEDICATION

To my parents — Hugh Quinn and Bridget Ryan — honest, loving and good people

ACKNOWLEDGEMENTS

Many, many people have helped to shape, educate and change me over a period of six decades. I salute you all, but I am specifically indebted to contributors to my radio programmes whom I have liberally quoted in this book.
John Quinn

The lines from 'To the Man After the Harrow', 'If Ever You Go to Dublin Town' and 'Lines Written on a Seat on the Grand Canal, Dublin' by Patrick Kavanagh are reprinted by kind permission of the Trustees of the Estate of the late Katherine B. Kavanagh, through the Jonathan Williams Literary Agency. The lines from *Translations* by Brian Friel are reprinted by kind permission of the author. The lines from 'A New Siege' by John Montague from *Collected Poems* (1995) are reprinted by kind permission of the author/translator; The Gallery Press, Loughcrew, Oldcastle, County Meath, Ireland. The lines from 'The Northern Ireland Question' by Desmond Egan, from *Elegies, Selected Poems 1974–2000* (Goldsmith Press), are reprinted by kind permission of the author. The quotation from Jenny Beale, from *Women in Ireland*, is reprinted by kind permission of the publishers Palgrave Macmillan. The lines from 'Digging' and 'Whatever You Say, Say Nothing' by Seamus Heaney are reprinted by kind permission of the author.

t was generally accepted in Irish journalistic circles for several decades after the Second World War ended that the Irish Press group had the best teams of news reporters and news photographers in the country. And within the photographic world it was acknowledged that Colman Doyle was the best of the best. Even when the Press group began to fall on evil times, ultimately crashing out of the ranks of Irish newspaper players, Colman continued to perform at the upper reaches of the premier league, covering Irish and world events for *Paris Match* and other agencies.

What gave Colman his special edge is hard to say. Certainly something is owed to his distinguished English photographic mentor, Norman Ashe, who gave him his early grounding in photography; something else to the Crossmaglen ancestry which gave him a special empathy with events in the North as the 'Troubles' unfolded.

This was not merely an empathy with the nationalist community. Colman and I once covered the 'green' twelfth in Rossnowlagh, County Donegal, as part of a Homeric tour of Northern Ireland to cover the 'twalfth' celebrations, during which we secured a memorable interview with a young Protestant preacher called Ian Paisley, who was at the time building a new church, the Martyrs Memorial, on the Raven Hill Road in Belfast.

There are three other ingredients in Colman's character which have gone into the making of a great photographer. One is interest. He was and is interested in anyone and anything which would make a good photograph, be it a child at the seaside, an old countryman, a facet of Irish life, or an up-and-coming young model, like Liz Willoughby, who, aided by Colman's lens, grew to be the Irish super model of the 1950s and 1960s.

His second principal characteristic is professionalism. He knows how to be in the right place at the right time. His talent for scouting the land beforehand — a talent that has enabled him to select the right jump, at the right race meeting, to get some incredible pictures of horses in mid-air — gave rise to two of my favourite Colman anecdotes. One goes right back to the destruction of Nelson's Pillar by the IRA in 1966. The

bomber merely had to place an alarm-clock-triggered device halfway up the column to bring it down in the small hours of the morning, without breaking a window in O'Connell Street. But the Irish Army was left with the more substantial task of demolishing the heavy plinth on which stood the remaining stump.

The event attracted worldwide media attention. Two continental photographers had hired a shop at the corner of Henry Street so as to be on the spot for Nelson's final departure, and they offered Colman a place in the window. Both shook their heads sadly when Colman politely declined the offer, saying he had another spot booked a hundred yards further up the street.

'*Ach*, Colman, you don't know how to get a good picture,' said one of the sophisticates with a sigh.

'No,' replied Colman, 'but I do know the Irish Army!'

There ensued one of the greatest explosions seen in Dublin since 1916, which not merely blew in every window in O'Connell Street, but hurled the two photographers and their equipment arse over tip across their shattered shop.

Next day they limped shamefacedly into the *Irish Press* offices to obtain from Colman some of the spare prints from his world-acclaimed shots of the blast.

Last, but far from least, Colman's other great characteristic is courage. Sometimes it takes unusual nerve to be in the right place at the right time. I remember a civil rights demonstration in Newry in which, again, continental photographers lined the rooftops above a barricade of buses which the protestors were attempting to breach.

A terrific mêlée broke out as demonstrators forced a way through the police cordons and began trying to push over the barricade. Missiles were thrown and everybody, including the roof-top photographers, ducked for shelter. As I moved backwards a movement on top of one of the now dangerously swaying buses caught my eye. It was a photographer in a crash helmet, getting the picture – Colman Doyle was once more in the right place at the right time.

It is a boon for Irish society that he and his camera were here to record this place in our time. I recommend this important book.

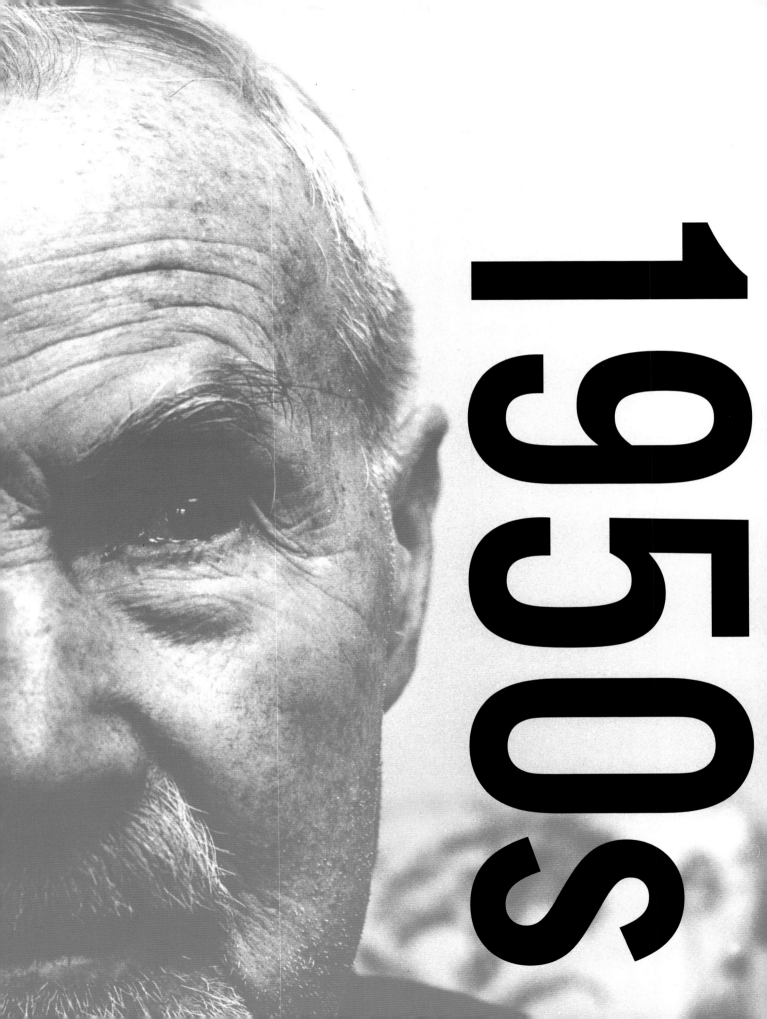

1950s

Panmunjom, the Thirty-Eighth Parallel, Suez, Mindszenty, Mau Mau … faraway places (and people) with strange-sounding names, in the words of a popular song of the period. To a boy approaching his teenage years in the 1950s these names tumbled out of radio waves or bobbed up on newspaper headlines. Indeed they were strange-sounding. Indeed there was a war in Korea, a crisis in Suez, dark happenings in the dark continent, and we prayed for the brave cardinal who opposed those bad communists — but all these things were happening far away. Far, far away from a little island on the edge of Europe, self-contained, self-possessed. Even further away from a quiet midlands village where — to misquote a comment on *Waiting for Godot* — nothing happened all of the time. The name of the village was Ballivor, in County Meath. The town of Ivor. An undistinguished backwater, dominated by the Catholic and Protestant churches squaring up to each other at the top of its one street. There was a saying about the village. Its origin was obscure but it was none too complimentary about the hospitality of the midlands hamlet — 'Goodnight Ballivor, I'll sleep in Trim …'

Forty years later, I would write a ballad in praise of the village but then, midway through the twentieth century, Ballivor was a quiet, secure, sheltered place to grow up in…

In Joe Mc Laughlin's General Stores
(Or as the signboard said — General Joe Mc Laughlin Stores)
They sold Indian meal and women's drawers
Rat-traps, rashers, six-inch nails,
Pints of porter, stout and ales
Oh goodnight Ballivor, I'll sleep in Trim.

So there was little to fear from Koreans or communists or Kenyan terrorists as that young boy set off for school while his father reassuringly hummed along with the signature tune of *Housewives' Choice* on the BBC Light Programme.

I write of Ballivor because it was my village, but it was also Everyvillage. The pace of life was slow and largely undisturbed. My father was the local garda sergeant, for whom unlighted bikes were the most serious crime, followed by 'found on premises' and uncut thistles (the Noxious Weeds Act was prominently displayed in the barracks). I have a vivid memory of a trivial incident which amply illustrates the almost static pace of daily life. I run home from school for my dinner (and the midday meal was dinner) to find my father chatting with Jim Dargan, standing by his horse and cart in the middle of the street. What neither man notices is the horse's mighty hoof pinning the paw of our unfortunate dog, Roy, to the road. Amazingly, the dog was uncomplaining until I released

OPPOSITE: An islander from the Great Blaskets. The last Blasket inhabitant was taken off the island in October 1953, thus ending a way of life that generations had endured in primitive conditions. For all that, island life produced three great autobiographical works – Muiris Ó Súilleabháin's *Twenty Years A-Growing*, Peig Sayers' *Peig* and Tomás Ó Criomhthain's *The Islander*, which famously concluded with the line '*Ní bheidh ár leithéid arís ann*' (our likes will not be seen again).

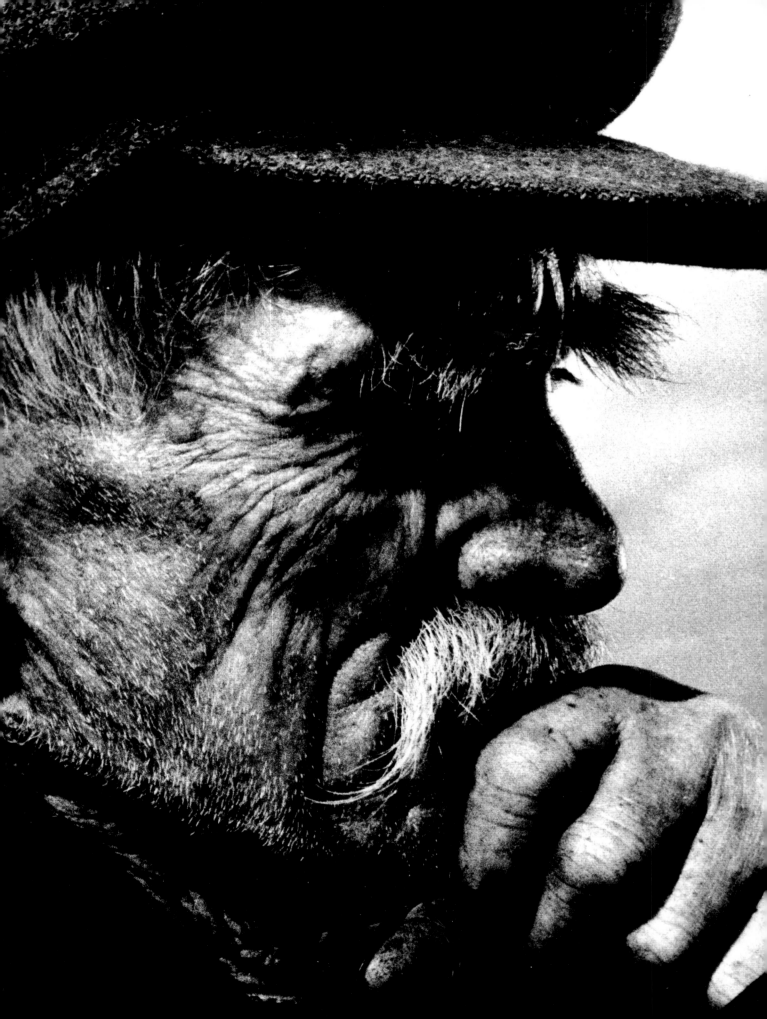

BELOW: Unwillingly to market – a bullock is coaxed across the Shannon bridge at Rooskey, County Roscommon.
TOP RIGHT: Blasket islanders landing sheep on the mainland at Dunquin. Although life on the island was tough, Peig Sayers recalled that there was *'plenty of everything on the island. Everyone had enough food, along with the hunting of hill and sea. No house was without a cow and many had two cows ...'* And many had sheep too.
BOTTOM RIGHT: Summer flooding on the Shannon.

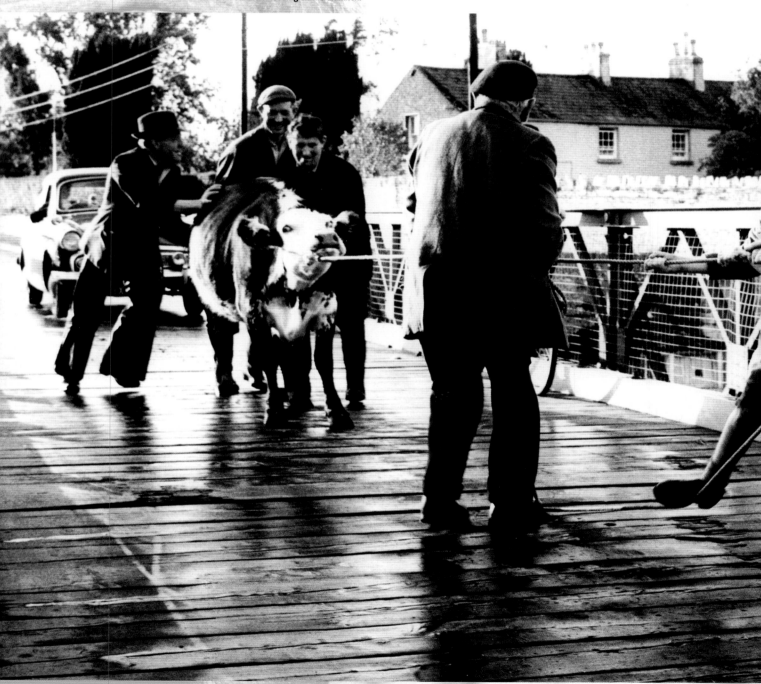

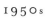

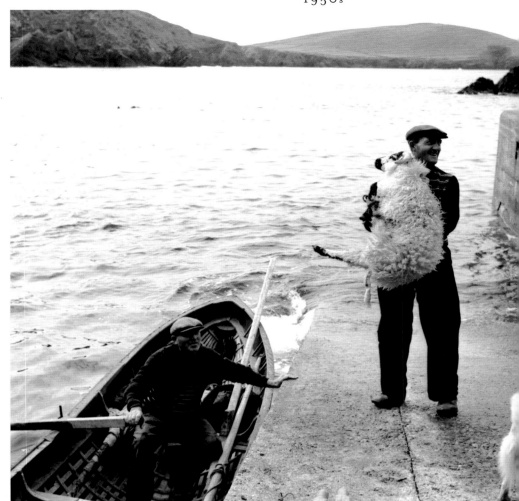

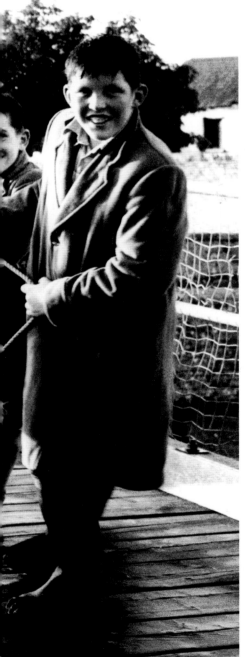

him, whereupon he whimpered away with a squashed paw.

A visit to the nearest town, Trim, would be a rare treat. An occasional shopping trip to McConville's Drapery or McGonigle's Shoe Shop with the added bonus of a call to Moore's Newsagents for the *Dandy*, the *Beano* or my own favourite, *Radio Fun*. A very special treat would be a Sunday night visit to the Royal Cinema. Our home entertainment was, of course, the radio. Despite Raidió Éireann's limited broadcasting hours, we thrilled to Micheál O'Hehir's Gaelic games commentaries, took the floor with Din Joe's dancing on the radio and enjoyed the Sunday-night play. My favourite radio programme came from another culture, however. I followed the daring exploits of the BBC's Dick Barton, Special Agent, and constantly feared for my hero's wellbeing. Other entertainment was provided by the travelling theatre and variety shows — the 'fit-ups' — but by far the greatest thrills came when Siki Dunne brought his filmshow to Sherrock's Garage on a Sunday night.

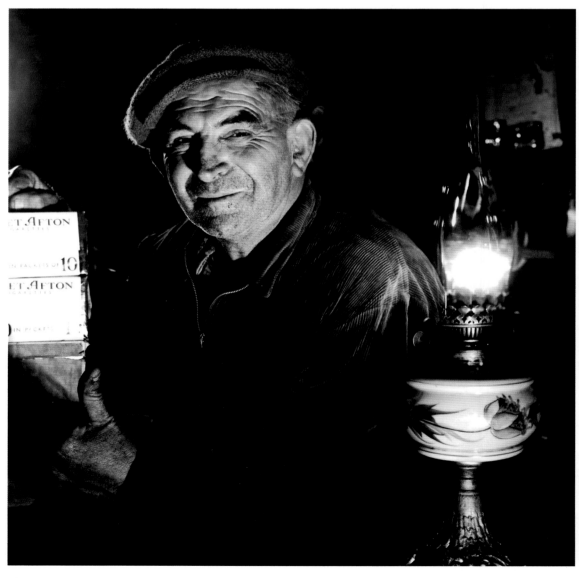

'Next Attraction — James Cagney in WHITE HEAT —
For one night only — full supporting programme —
Eight-thirty p.m. SHARP!'
(In other words no dawdling after devotions, folks)
Dawdle?
We shed our surplices and candle-greased soutanes
With unholy zest
And scuttled down the street
Lured by the siren strains of Rosie Clooney's
'Comeonamyhouseamyayhouse ...'
Deserting God for a shilling dose of Mammon.
And there, careless of grease-pocked wooden seats,
Oil-soaked sawdust and icy draughts,
We surrendered to the celluloid world
And warmed in the glow of Cagney's White Heat.

OPPOSITE: A thumbs-up welcome to his County
Kerry pub from 'Kruger' Kavanagh, fisherman
and guesthouse-owner. The elegant oil-lamp
marks pre-electrification days and Carroll's
'Sweet Afton' cigarettes are in
plentiful supply.
ABOVE: Christy Murphy contemplates another
pint in Mulligans of Poolbeg Street, Dublin,
on Bloomsday (16 June).

Later we fought a famous gunbattle in the shadowy street
Dropped into 'Sam's' for bourbon with ice,
Slapped Mickey Fagan behind bars
And raced off home as he cried
'You guys! You guys can't pin this rap on ME!'

Next morning in the frosty light
There was no Plaza but Sherrock's Garage
And 'Sam', the village pump, stood stiffly
In his regulation County Council coat of straw.
Someone had sprung Mickey Fagan too —
The hoary church gates lay open
As we trooped back to serve our other master
(Mass begins at 7.30 a.m. SHARP, said Fr Farrell)
But Jimmy Cagney had blazed into our lives
For one night only ...

In truth, there were few opportunities to serve Mammon. The stern rule of Fr Farrell and his successors, allied to a strict home discipline, saw to that. And if you literally served God, as an altar-boy, your days and nights were consumed with Masses, holy hours, sodalities, benedictions, weddings and funerals — although the latter two were a welcome source of income, through altar-boys' 'tips' ... And there was the learning by heart of a strange language.

Introibo ad altare Dei
Ad Deum qui laetificat juventutem meam

Even the English language seemed strange, at times. Accompanying the priest on the Way of the Cross, fearfully balancing a lighted candle almost as big as myself, I trembled as the celebrant enjoined us to 'compassionate your saviour, thus cruelly treated ...'
 Who or what was compassion, and why would it eat our saviour ...?

At Mass on Easter Sunday morning,
Fr Farrell intoned the dues with warning
'One shilling and sixpence each the following —
Thomas Dunne, Moyfeigher ...'
While Eugene Leddy de-waxed his ears.
Oh goodnight Ballivor, I'll sleep in Trim.

There is a saying — 'It takes a village to raise a child.' I found this to be very true in the Ballivor of the 1950s. Of course my parents lavished care and love on me. And of course Master Conway and Mrs McGearty taught me the rudiments at school. But Harry Garry in Mc Laughlin's shop taught me the value of a smile and a joke — and how to tie a parcel with string and not amputate your finger in the process.

The genial blacksmith, Bill Kelly, explained the secrets of his dark trade in his dark forge. When he came to our house each day for his dinner, he taught me how to play draughts, proclaimed himself 'The Champ' and offered me 'a crack at the title' every day until I eventually beat him. I learned about losing and winning.

And there was the Bord na Móna driver who took me in his lorry to exotic places like

Sunset on the Blasket Islands, viewed from Dunquin.

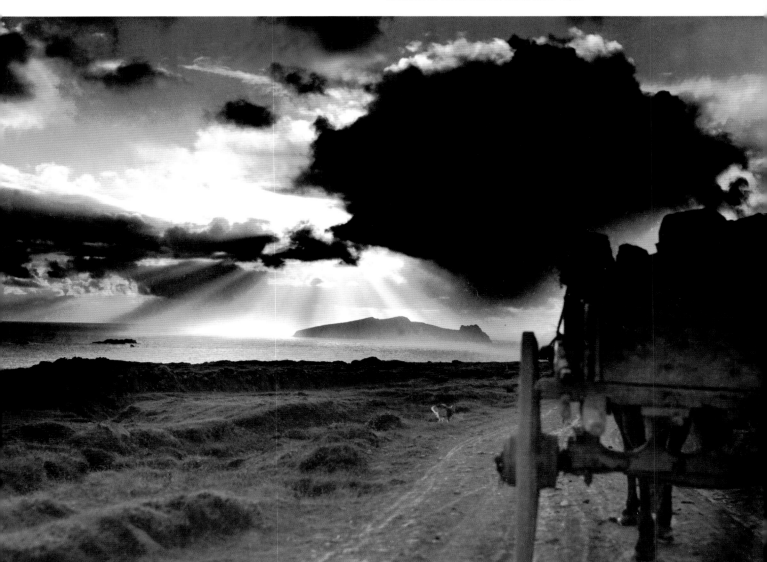

Rhode or Clonsast in County Offaly, bought me toffee and taught me the words of 'On Top of Old Smokey'. And Fr Murtagh, the curate, rewarded the altar-boys with a trip to Trim to see the local musical society's production of *New Moon* ... And was I ever afraid or had I ever cause to be afraid? No. I was simply cherished. And was I ever a public liability insurance risk? No. I was simply welcomed.

It was a simple life, almost a primitive life. Electricity had only recently come to the village, to the wonder of all. There was no running water or sanitation service. My brother and I argued constantly as we drew endless buckets of water from the village pump ('Sam's place'), sharing the load as we ran a hurley through the bucket handle ...

It was a self-sufficient life. My father kept a couple of cows (in the barrack out-houses), grew his own vegetables (in the barrack garden), saved his own turf and hay and kept a few pigs in the backyard. To augment the meagre garda salary, my mother kept lodgers (usually ESB and Bord na Móna employees) and raised turkeys, which came as chicks from the hatchery in a perforated box on the Dublin–Ballina bus. In many ways our village life reflected the aspirations of Éamon de Valera, the Fianna Fáil leader, for his country — self-supporting and self-reliant — 'a land whose countryside would be bright with cosy homesteads, whose fields and villages would be joyous with the sounds of industry ...'

For most of the 1950s, however, de Valera's ideals were far from realisation. The economy was stagnant. The only escape for many was the emigrant boat. Some 400,000 took that option between 1951 and 1961. In a radio talk, the writer Seán O'Faoláin famously declared, 'The only world open to the Irish soon will be the next one.' As many of Colman Doyle's photographs graphically illustrate, Ireland had changed little physically since independence.

Other aspirations of de Valera's Ireland were closer to being realised, however. The playing fields of Ireland echoed to the contests of sporting youths in Gaelic football and hurling. In 1949 Meath won their first ever All Ireland football title. How we celebrated! A torchlight procession (blazing sods of turf impaled on long poles) and a massive bonfire, around which we gathered for our very own 'Sunday Game'. Joe Dempsey, our Micheál O'Hehir impersonator, replayed the entire match, complete with every O'Hehir cliché:

'Meath always the bridesmaid, never the bride ...'

'Mc Dermott pretends to go left, goes right ...'

We cheered every Meath score, booed every Cavan foul and toasted our hero-warriors: Paddy 'Hands' O'Brien, Frankie Byrne, Peter 'The Man in the Cap' McDermott and Ballivor's very own Paddy 'Stonewall' Dixon.

In her autobiography, Peig Sayers recalls that in her time there were fourteen cradles rocking babies on the Great Blasket ... The *bean chabhartha* or midwife was an important figure on the island. Pictured here, complete with *dúidín* (clay pipe) is the midwife, Méiní Chéitinn, who had lived in America before coming home to settle on the island.

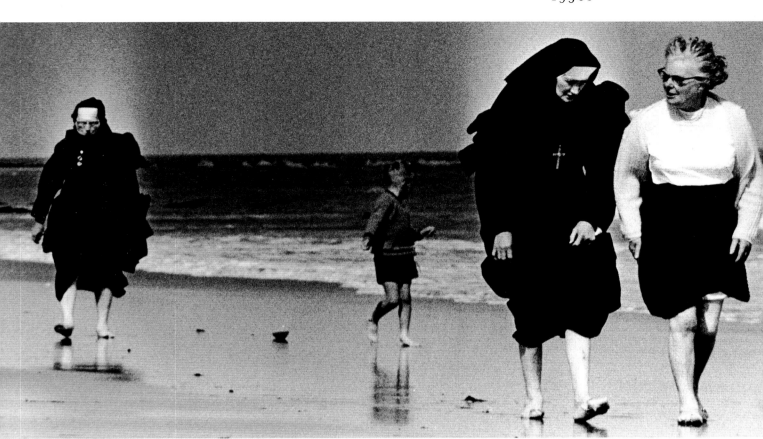

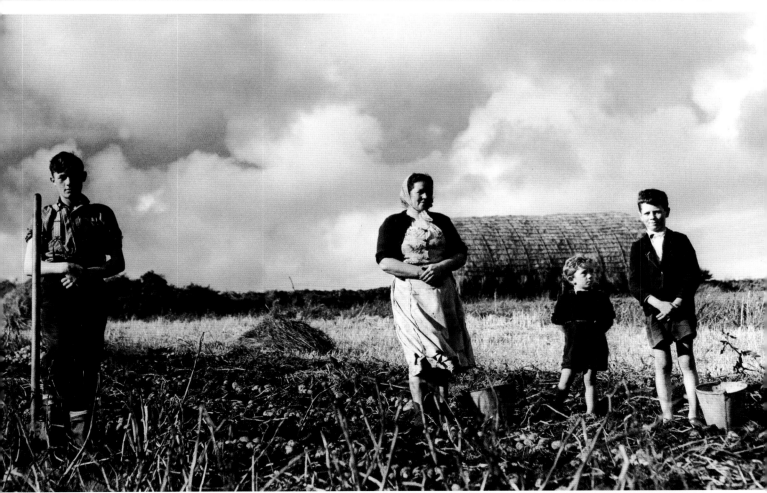

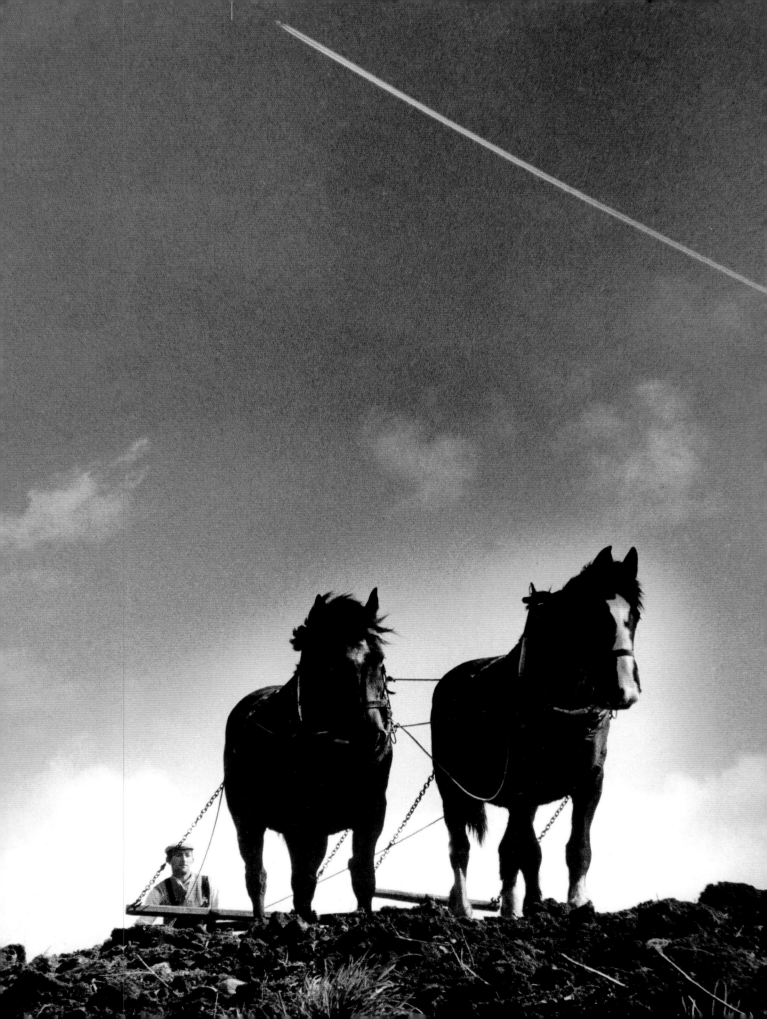

LEFT: '*Now leave the check-reins slack*
The seed is flying far today ...'
(Patrick Kavanagh, 'To the Man After the Harrow')
The old Ireland – harrowing with a team of horses in Liscannor, County Clare – set against the new – jet-trails in the
sky as a transatlantic jet sets off from nearby Shannon Airport.
BELOW: Two brothers by the fire in their home at Lahinch, County Clare. Note the ironic juxtaposition of the picture
of an aeroplane amid sides of bacon being 'smoked' over the fire. The aeroplane would be no more than a dream for
the brothers. Colman Doyle notes that they 'never went further from home than to Mass or to Mary Comer's pub'.

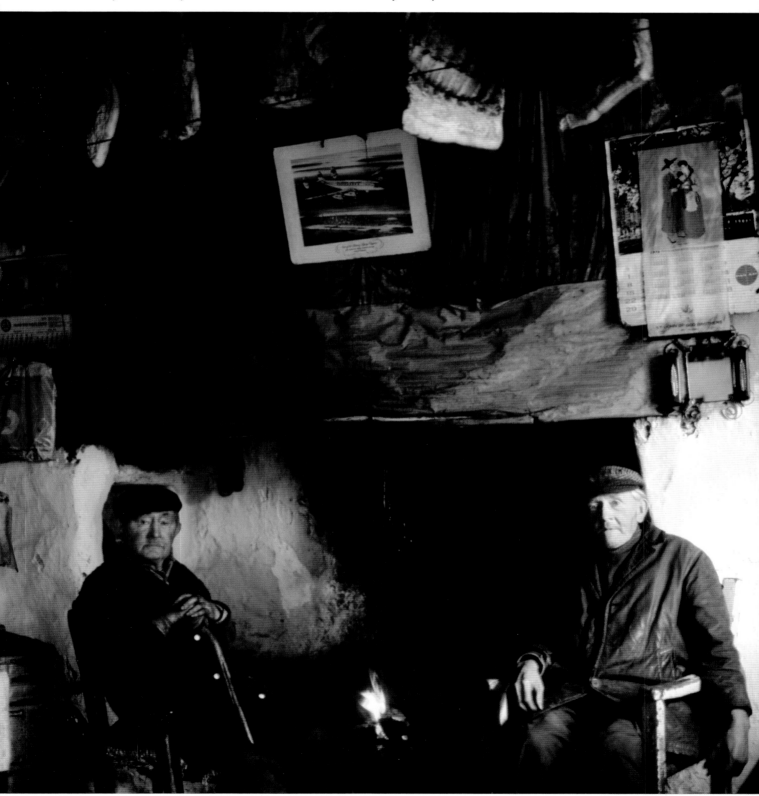

alley, you might well have forfeited that luxury for an entire term ...) The day ended, as it had begun, with communal prayers when we invoked the Lord's protection in the words of the Brothers' patron:

> *Christ in the fort*
> *Christ in the chariot*
> *Christ in the ship*
> *Christ in the heart of every man who thinks of me*
> *Christ in every eye that sees me*
> *Christ in every ear that hears me ...*

('St Patrick's Breastplate')

The Brothers did their best to replace the comforts of home. A film-show on Sunday night, which only made one long for the luxury of the 'Princess'; a solitary radio in the middle of the study-hall; and, latterly, a record club which brought us the hitherto forbidden delights of the skiffle music of Lonnie Donegan, the crooning of Pat Boone, the

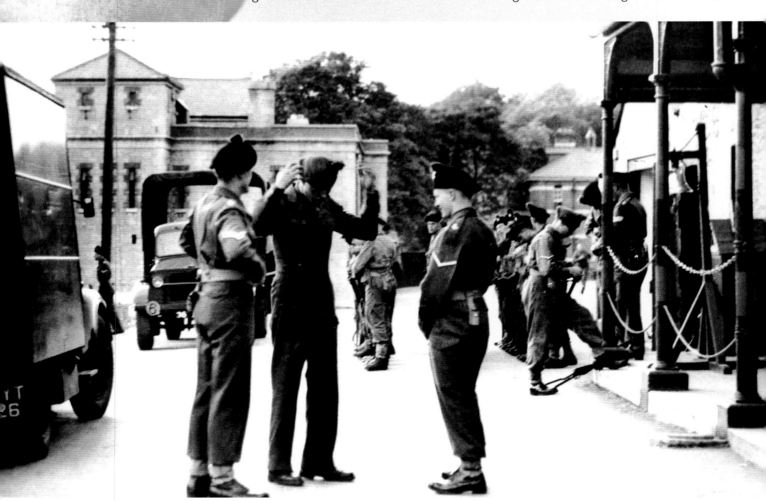

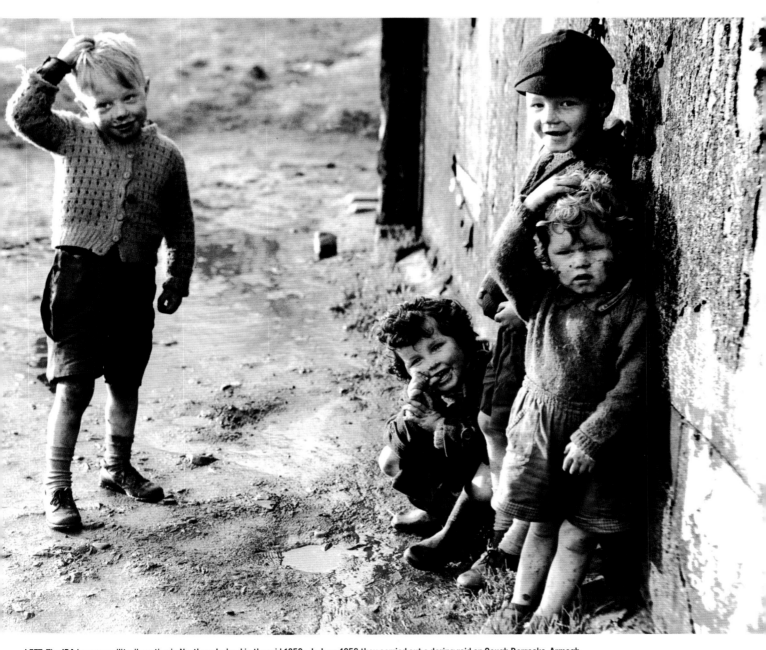

LEFT: The IRA became militarily active in Northern Ireland in the mid-1950s. In June 1956 they carried out a daring raid on Gough Barracks, Armagh, where they seized 300 Lee Enfield rifles and a quantity of Bren guns. Picture shows Gough Barracks in the aftermath of the raid.

ABOVE: A scene that could easily be from the 1920s. Tintown Estate in Derry, a former US army camp, became home for Catholic families when they were moved there after the war. Conditions were squalid in the extreme.

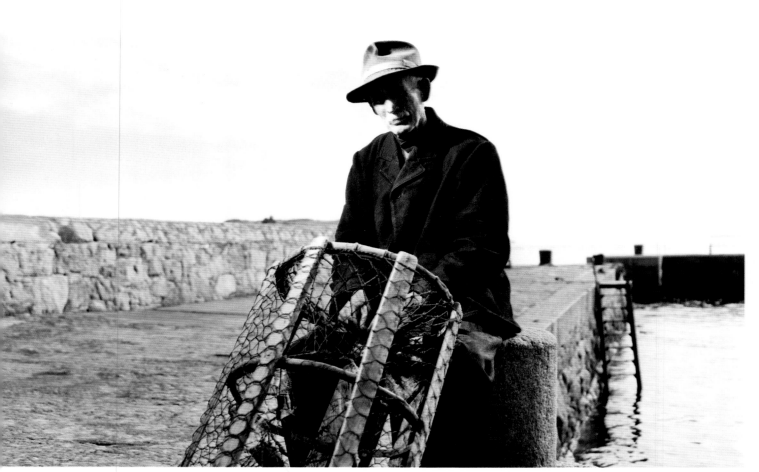

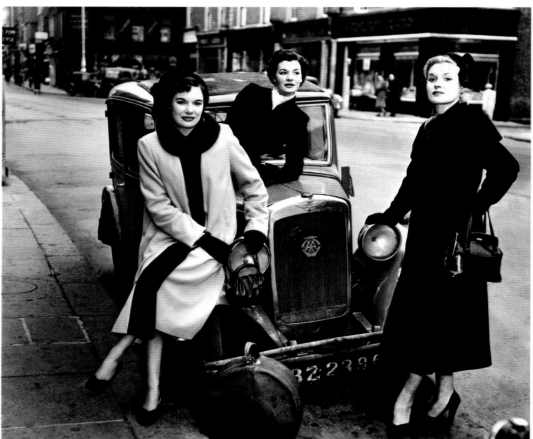

shock of Bill Haley's rock-and-roll and the electricity of the latest sensation, Elvis Presley. We teenagers were drifting inexorably beyond the ken of Éamon de Valera's aspirations …

The radio, occasional newspapers and letters from home were our links with the outside world. (The letters were particularly welcome when the already-opened envelope – censorship! – had the magical words 'ten shillings' inscribed on it. This signified that my parents' ten-shilling note had been removed from the envelope and lodged to my tuck-shop account …)

The radio brought us news of the spread of a strange disease called myxomatosis, which was bad news for rabbits … a series of IRA attacks in Northern Ireland … and the death of Pope Pius XII. But the greatest news of all came from the other side of the world on a raw December morning in 1956. A BBC commentator, barely discernible in a crackling short-wave broadcast, informed us that the men's 1,500 metres at the Olympic Games in distant Melbourne had been won by 'Delaney from Éire' (his main concern was that the Briton, Brian Hewson, failed to make the first three …). Our joy knew no bounds. Each one of us wanted to be a Ronnie Delaney. Each of us *was* a Ronnie Delaney. Some fifteen months later, in February 1958, came the horrendous news of the Munich Air Disaster. My friend Des Brady was devastated at the loss of his brilliant hero, Duncan Edwards, and six other of his Manchester United colleagues – the 'Busby Babes'.

TOP LEFT: John 'Gunger' Hammond, one of a noted seafaring family, pictured at Coliemore Harbour, Dalkey.
BOTTOM LEFT: Three models and a vintage model! Dorothy Flynn, Peggy Cullen and Betty Whelan bring a bit of glamour to a drab and traffic-empty Baggot Street in Dublin.
BELOW: Still in the age of steam. A train winds its way from Dalkey to Killiney (an early Kodachrome photo).

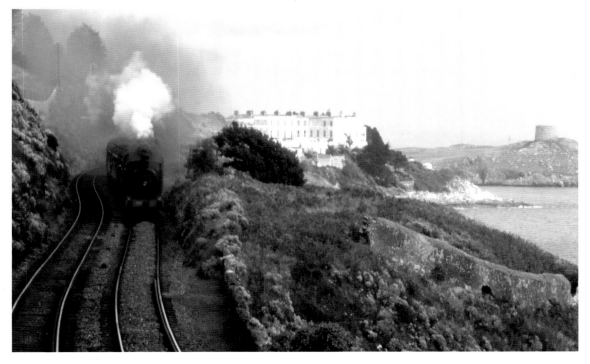

We wished our lives away as we marked off the days to the end of term in copybooks and textbooks (fifty-nine days to go — roll on Christmas …). A term was of course a *full* term — no weekends off or mid-term breaks. If you were lucky enough to have parents who owned a car (and many were not), you might have an occasional visit or 'call' when much-needed food supplies were provided. Tins of sardines or cans of beans meant that you were particularly popular for a brief period at the refectory table.

The years slid by. The year 1959 was Leaving Cert year and there were decisions to be made. Career Guidance was minimal, so you had to make your own mind up. The Bank? The Civil Service? Teaching? University (if you could afford it)? Primary Teaching for me. The 'call' to teacher-training was based on total aggregate marks in the Leaving Cert exam. Agricultural Science carried 400 marks, Commerce only 300. And so I elected to study the merits of the dual-purpose cow, the correct mix of grass-land fertilisers and the distinctive traits of several breeds of sheep — all so that I could become a primary teacher! And it paid off. In September 1959, I enrolled for a two-year course in St Patrick's Training College, Dublin.

Back to the city. The grey, grimy, smog-ridden city. I remember walking through dense smog from Rathmines to the Theatre Royal to attend a performance of Handel's

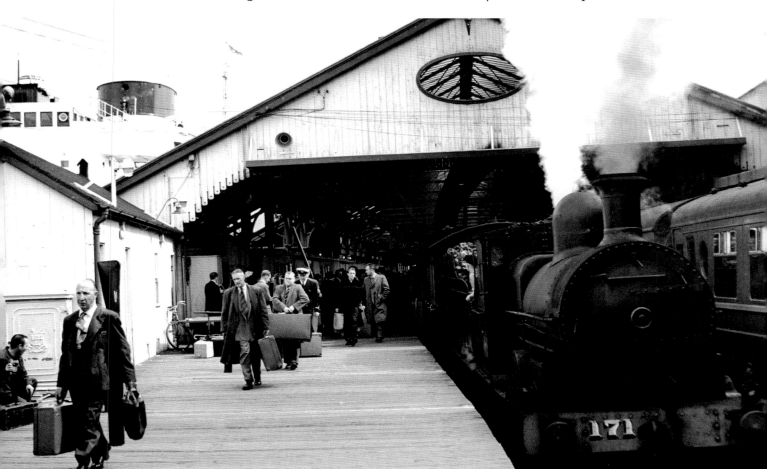

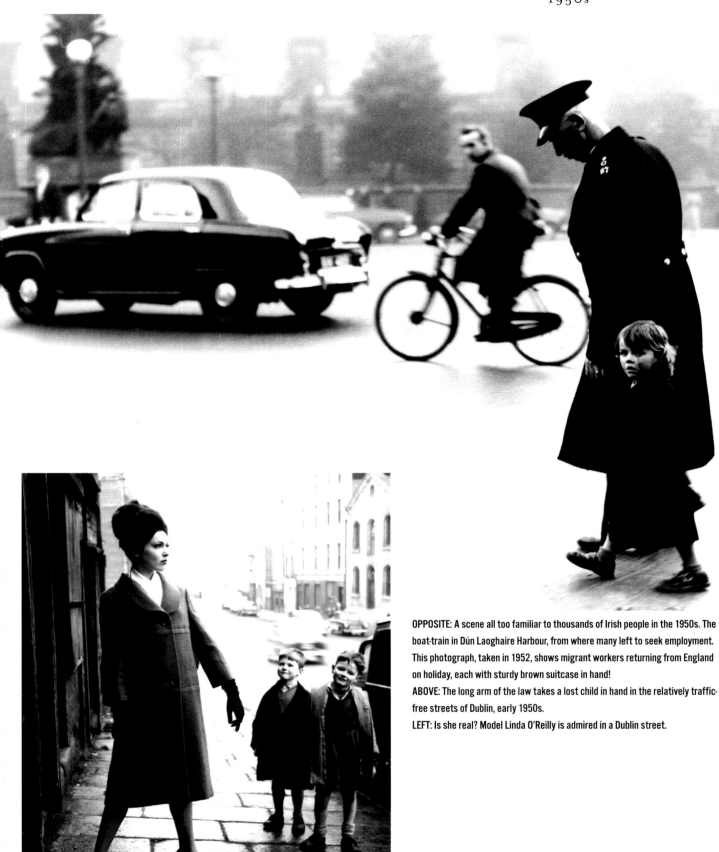

OPPOSITE: A scene all too familiar to thousands of Irish people in the 1950s. The boat-train in Dún Laoghaire Harbour, from where many left to seek employment. This photograph, taken in 1952, shows migrant workers returning from England on holiday, each with sturdy brown suitcase in hand!

ABOVE: The long arm of the law takes a lost child in hand in the relatively traffic-free streets of Dublin, early 1950s.

LEFT: Is she real? Model Linda O'Reilly is admired in a Dublin street.

Messiah, John Barbirolli conducting the Halle Orchestra. I was the hero of the evening as I had a flashlight to pierce the gloom and soon discovered I was leading an Indian-file expedition in search of the Messiah ...

Summer days were full of light and carefree living. The Olympic victory of Ronnie Delaney had initiated a whole new interest in athletics and the optician/impresario Billy Morton promoted a series of hugely popular meetings in the newly opened Santry Stadium. Queues snaked down O'Connell Street in Dublin for special buses to take the fans to Santry, where the redoubtable Billy, anxious to pack everybody in, stood on the new cinder track and bellowed through his loud-hailer — 'Would yis kindly infiltrate up to the back of the terrace, please?' On a memorable evening in 1958, we packed and infiltrated to watch the great Australian Herb Elliott destroy the field in the Invitation Mile to the extent that the first five runners home beat the magical four-minute barrier that Roger Bannister had first broken four years earlier. Five four-minute miles in one race — an unheard-of achievement. Little wonder that Billy Morton had to chase off souvenir-hunters who tried to fill matchboxes with cinders from his record-breaking track ...

And summer for me was tennis — not the playing of it, but the watching of it. I had become attracted to the game through listening to Max Robertson's fascinating BBC radio commentaries from Wimbledon:

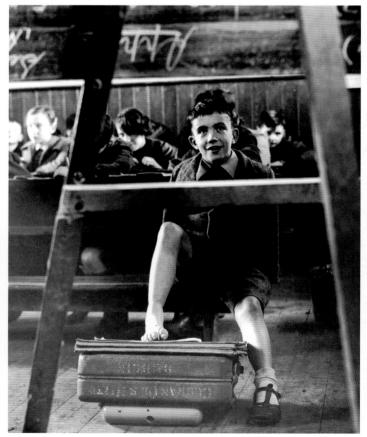

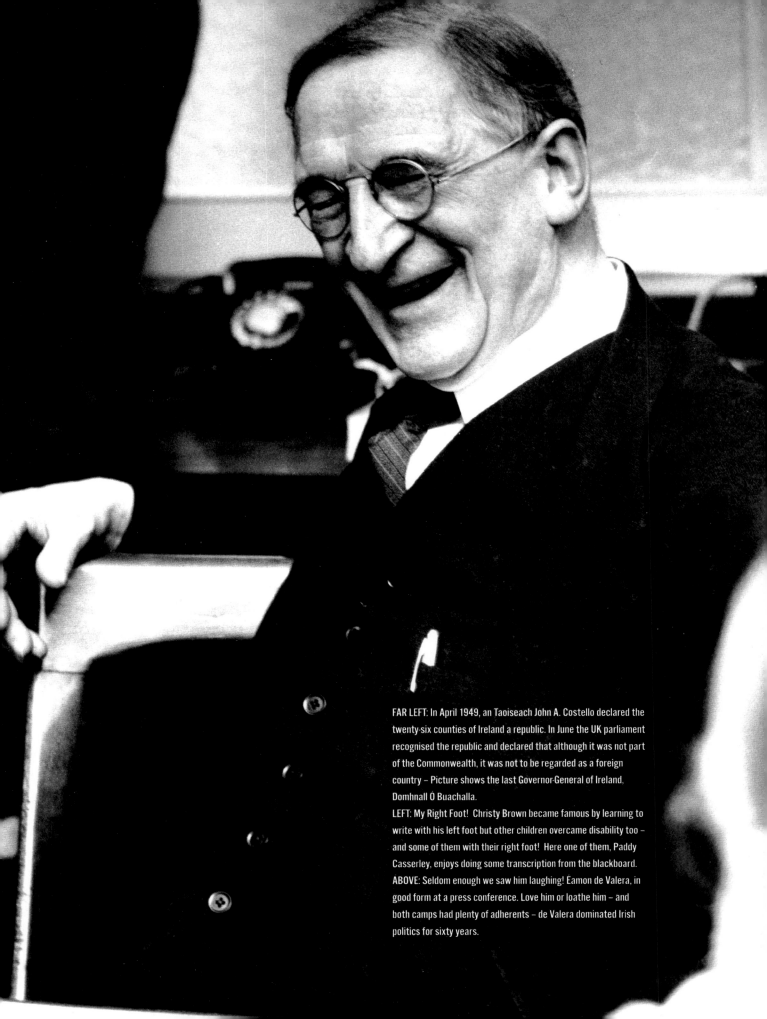

FAR LEFT: In April 1949, an Taoiseach John A. Costello declared the twenty-six counties of Ireland a republic. In June the UK parliament recognised the republic and declared that although it was not part of the Commonwealth, it was not to be regarded as a foreign country – Picture shows the last Governor-General of Ireland, Domhnall Ó Buachalla.

LEFT: My Right Foot! Christy Brown became famous by learning to write with his left foot but other children overcame disability too – and some of them with their right foot! Here one of them, Paddy Casserley, enjoys doing some transcription from the blackboard.

ABOVE: Seldom enough we saw him laughing! Éamon de Valera, in good form at a press conference. Love him or loathe him – and both camps had plenty of adherents – de Valera dominated Irish politics for sixty years.

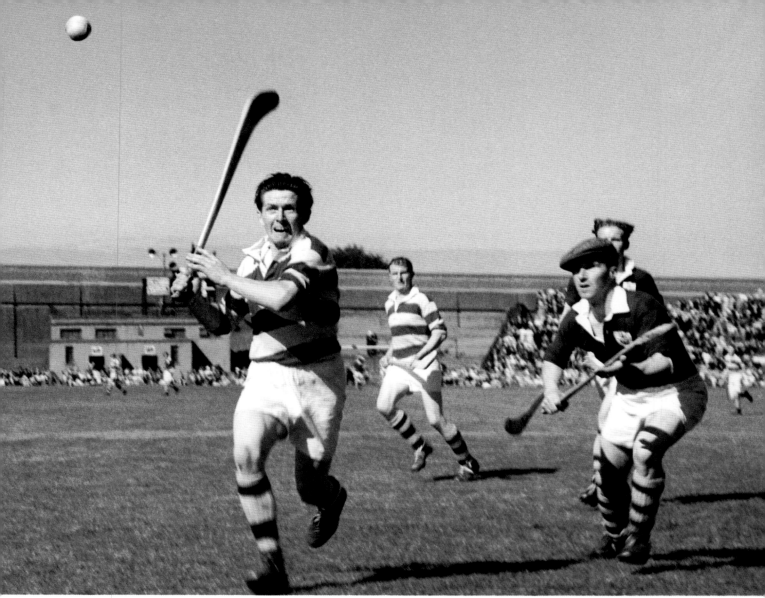

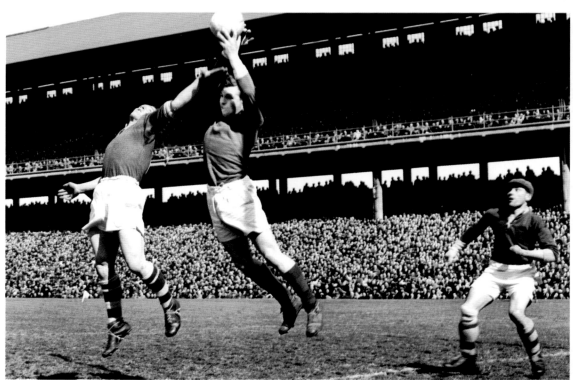

LEFT: All eyes on the ball! Wexford were a dominant force in hurling in the mid-1950s. Picture shows two of their stars (in hooped jerseys) – Tim Flood (nearer camera) and Nicky Rackard – one of the great trio of Rackard brothers. Nicky was a deadly full-forward who, it was said, 'could ring the parish priest's doorbell at twenty yards with a belt of the *sliotar'*. Galway's Jim Brophy (with the cloth cap) and Frank Flynn are on the right.

BOTTOM LEFT: Paddy Prendergast of Mayo gets to grips with a high ball, during the Meath and Mayo GAA league final, Croke Park, 22 April 1951. Meath players are (left) Jimmy Reilly and (right) Peter McDermott.

BELOW: Our great sporting icon of the 1950s, Ronnie Delaney, winner of the 1,500 metres gold medal at the Melbourne Olympics 1956, preceded here by the colourful athletics impresario, Billy Morton. Morton, a Dublin optician, packed Santry Stadium regularly with top-class athletics meetings, featuring such stars as Delaney, Brian Hewson, Gordon Pirie, Murray Halberg and the great Herb Elliott.

BOTTOM: A classic delivery from the scrum! French scrum-half Gerard Dufau during the Ireland–France rugby match at Lansdowne Road, Dublin, 1951. Note the old stand in the background.

Pages 36–37:

LEFT: Dramatist Noel Coward in Dublin for the staging of his play, *Relative Values*, in 1953. Aer Lingus made history by flying in the entire stage setting from London.

RIGHT: Straight from the horse's mouth! Hollywood director John Huston in conversation with an equine friend at home in Craughwell, County Galway.

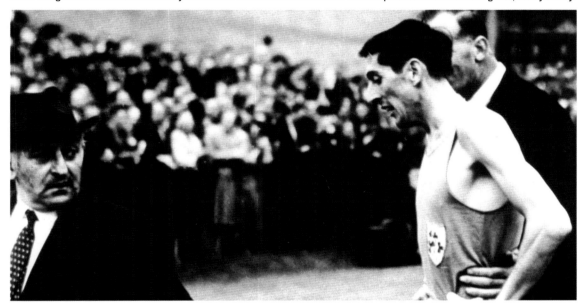

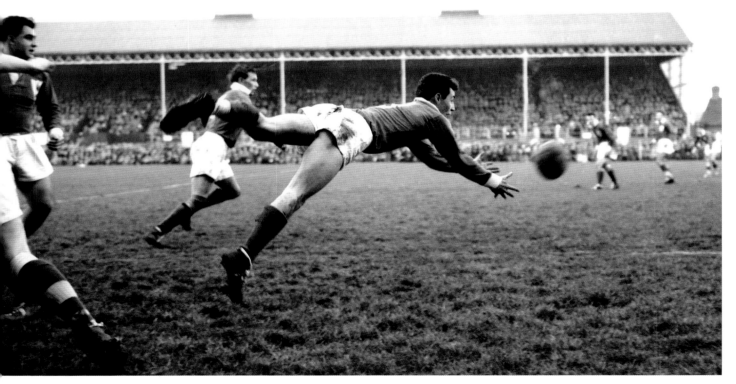

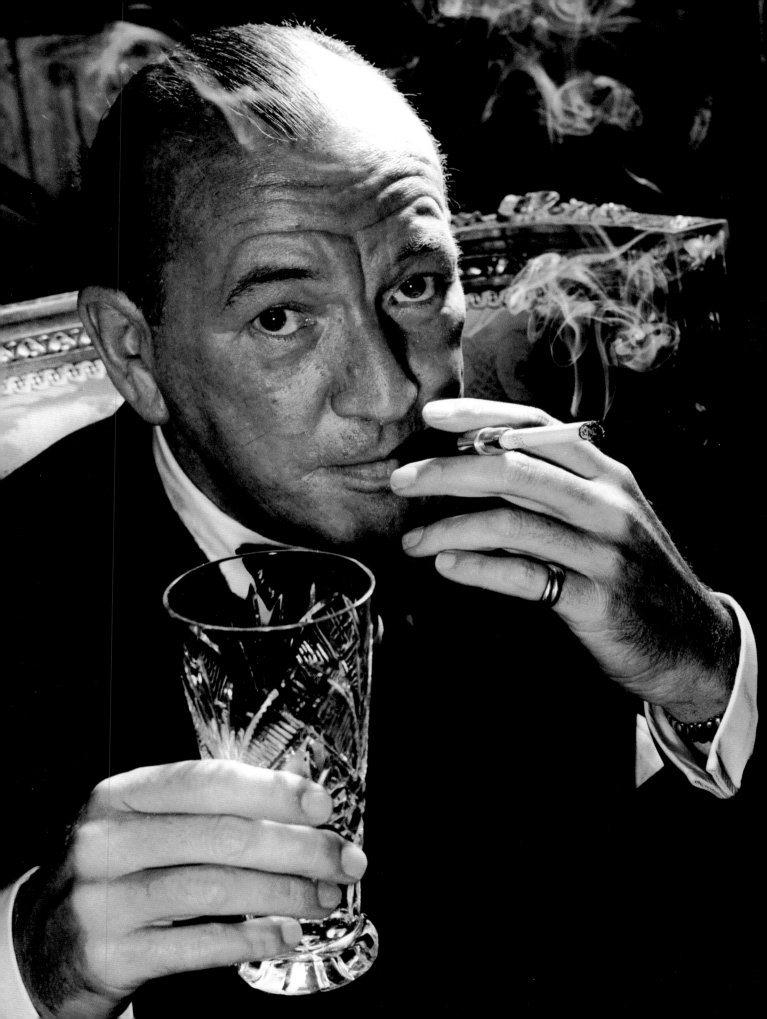

Rosewall plays a delicate drop-shot ... Hoad whips a crosscourt forehand deep to the baseline ... Rosewall scurries back, hoists a high defensive lob ... Hoad smashes ...

All the tennis greats came to the Fitzwilliam Club in Dublin for the Irish Open Championships – Lew Hoad, Jaroslav Drobny, Ashley Cooper, Maria Bueno – but they all paled in comparison with the lovely Sandra Reynolds who was tall and elegant and simply beautiful, her graceful movements like the gazelle of her native South Africa ... Forty years later I would immortalise Sandra in the radio documentary, *Ballyfin*:

> *He scraped together the half-crown admission fee each day, just to be close to Sandra Reynolds. She was – perfection. He had written to her once at Wimbledon but no doubt she had a busy schedule. He understood. He loved Sandra Reynolds. Together they would be happy forever – even when they had retired after winning the Wimbledon mixed doubles for a record sixth successive time ...*

Teenage dreams. Passions. Fantasies. The 1960s would bring reality.

Beyond my teenage dream world there were more pragmatic dreamers at work. In November 1958, T. K. Whitaker, Secretary of the Department of Finance, published a paper on 'Economic Development'. It would become the basis for the White Paper – *A Programme for Economic Expansion* – which would radically alter economic policy from one of self-sufficiency to an open export-oriented policy. That policy would be driven by the equally pragmatic new leader of Fianna Fáil, Sean Lemass. Again, forty years later, it would be my privilege

as a broadcaster to interview the author of that paper and the architect of a new Ireland — Ken Whitaker.

> *We were the first privileged generation of a new Ireland. We had had a good education. Good jobs and here was a chance to apply what we had learned for the benefit of the country, as we saw it. That was a source of great satisfaction. I remember thinking how apt the words of William Wordsworth were —* 'Bliss it was in that dawn to be alive, but to be young was very heaven'

('My Education')

And in the last year of the decade, Mary Margaret Browne from Castlerea, County Roscommon, made history when she became the first female member of An Garda Síochána. A 'ban gharda'. As Bob Dylan would say in the upcoming decade: 'The times they are a-changing ...'

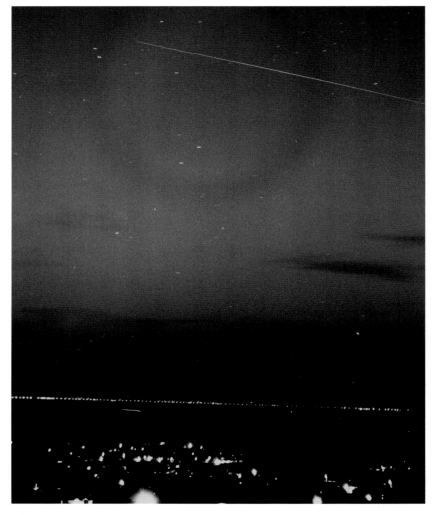

On 4 October 1957, Russia initiated the Space Age by launching SPUTNIK-1, the first man-made satellite. It orbited the earth at a distance of five hundred miles, taking ninety-five minutes to complete each orbit. Colman Doyle's picture, taken from Killiney Hill in Dublin, dramatically captures Sputnik's journey across the Irish night sky.

1960s

Let's dispense with the cliché straight away:

'If you remember the 'sixties, man, you weren't there ...'

Well, man, on that basis, I wasn't there. Of course I remember the 1960s — television, the Beatles, a vital young American president, a dead young American president, the Berlin Wall, free secondary education, man on the moon, Vietnam, Civil Rights, Flower Power, Jack Lynch, Arkle, the Troubles ... It was quite a decade, particularly compared with the sleepy 1950s. There was a sense of opening out to the world, an opening of minds and hearts; a sense of movement; a sense of the world beginning to become a smaller place. In January 1961 the last train ran on the West Clare Railway, a service much ridiculed by Percy French:

Do you think that we'll be there before the night? ...
Still ye might now, Michael, so ye might ...

Six months earlier, a few miles down the road, Pan Am airlines had introduced the first jet service from Shannon to the USA. Closing and opening. Saying goodbye and saying hello. From the same County Clare, a young woman had set off for the bright lights of Dublin and a career in writing. Her name was Edna O'Brien.

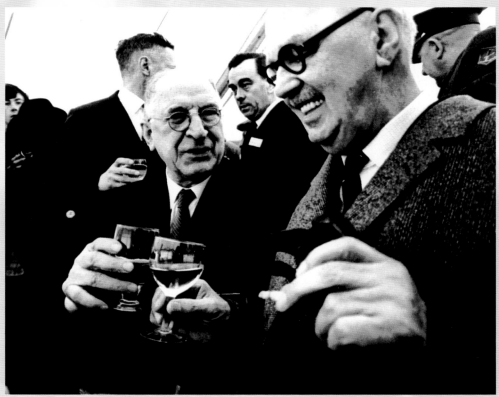

NEAR RIGHT: A toast to other times. Éamon de Valera meets up with Captain George Hickson, the British army officer who arrested him after the 1916 Rebellion. Obviously no hard feelings ...
OPPOSITE: Two big men who could literally see eye to eye! President de Valera entertains President Charles de Gaulle of France in the grounds of Áras an Uachtaráin, June 1969.

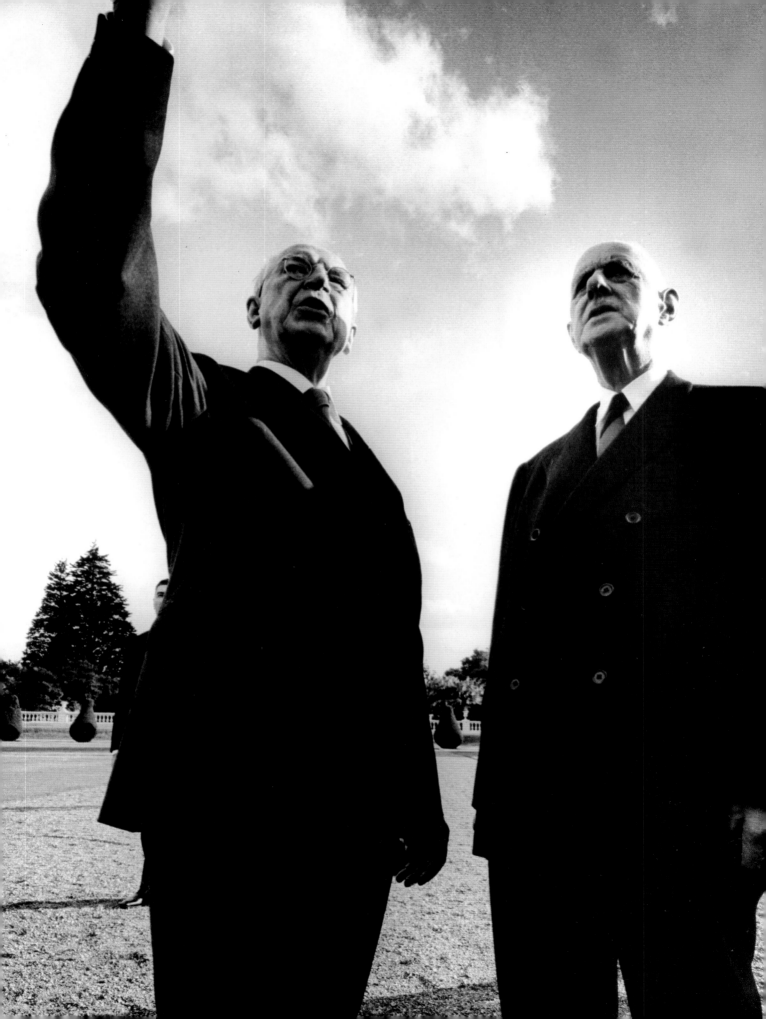

BELOW: Veterans of the 1916 Insurrection gather at the GPO Dublin for the fiftieth anniversary commemoration.
RIGHT: A word in your ear, Mr President! A little girl in her best summer finery, gets the undivided attention of President John F. Kennedy, during his visit to his ancestral home in Dunganstown, County Wexford, June 1963.

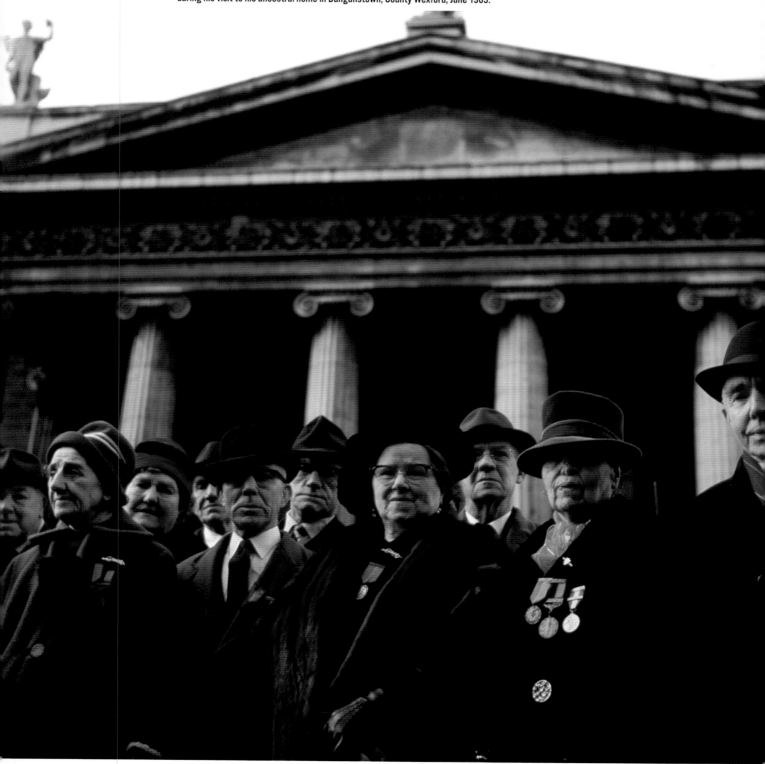

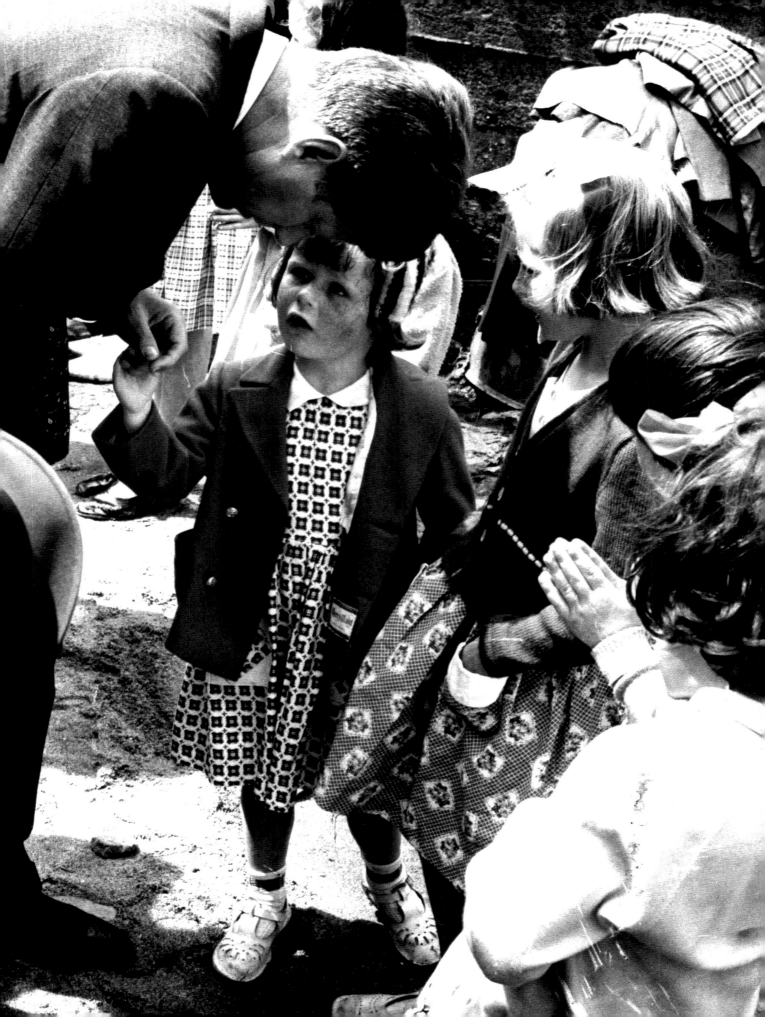

Goodbye to the humble little mounds, the ragwort, the chicken run, the dozey hens, goodbye to the tillage, goodbye to the green gate with its intractable hasp, goodbye to the ghosts wherein were contained all seeds of future laughter, skittishness and woe. Goodbye to the ineradicable past.

(Edna O'Brien, *Mother Ireland*)

Edna O'Brien's first novel, *The Country Girls*, was published in 1960. The heroine escapes from small-town life in the west of Ireland, comes to Dublin and has an affair with a Frenchman, 'Mr Gentleman'. It shocked many people (including Edna's former headmistress who wrote her a scathing letter, condemning her 'wicked book') and was promptly banned in Ireland. The 1960s would be the decade of revolutions and here

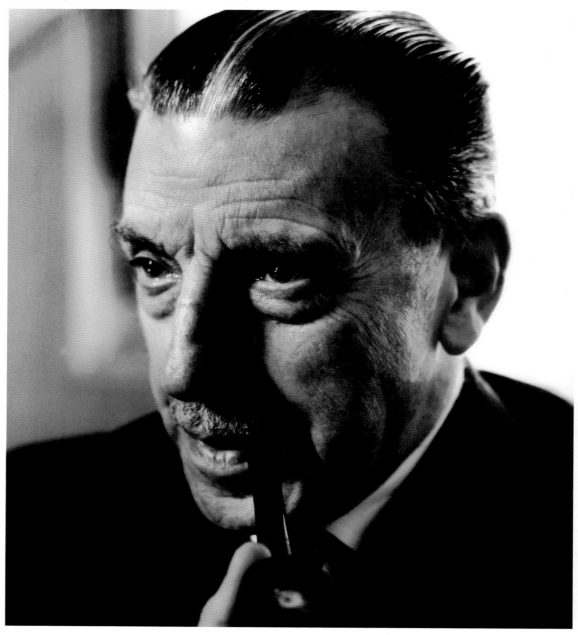

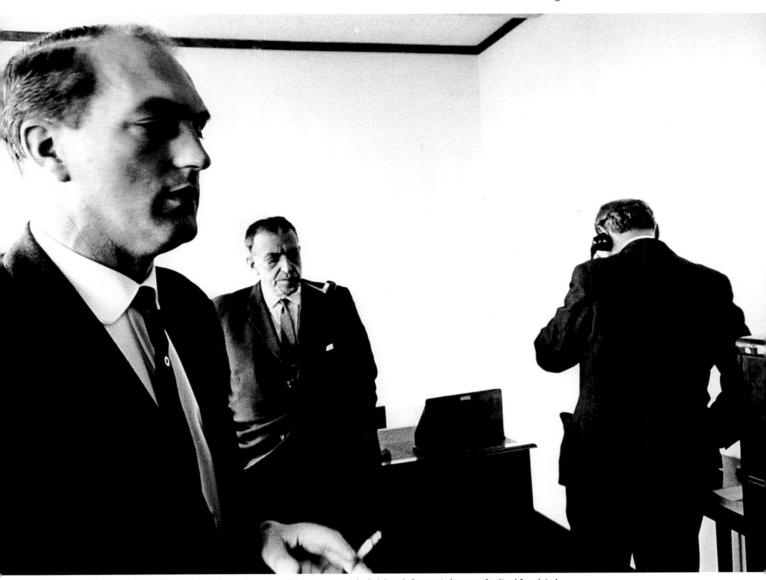

LEFT: Sean Lemass, described in 1946 as 'the best dressed member of the government, he indulges in frequent changes of suits...' Appointed Minister for Industry and Commerce by de Valera in the first Fianna Fáil government in 1932 and subsequently Minister for Supplies during wartime, he succeeded 'the Chief' as leader of Fianna Fáil and Taoiseach in 1959. Gruff in voice, brusque in manner and pragmatic in outlook, he broke away from his predecessor's protectionist and self-sufficiency policies to spearhead Ireland's economic development in the 1960s. He resigned in 1966 and died in 1971.

ABOVE: An historic moment, captured by chance by the ever-alert Colman Doyle. In November 1966, Sean Lemass (centre) resigned as Taoiseach and leader of Fianna Fáil. Both George Colley (left) and Jack Lynch (right) contested the succession. Lynch won and Colman Doyle was on hand to photograph the victor telephoning his wife Máirín with the good news ...

was the beginning of one of them — the sexual revolution in Ireland.

Of course I remember the 1960s, but they were mainly 'out there'. They were happening in swinging London, revolting Paris or hippy San Francisco ('make sure to wear a flower in your hair ...'). The world was about to become a global village, however, mainly through the advancement of television. When Telefís Éireann went on air on the last day of 1961, we were exposed to a whole new culture and way of life — very much an American culture thanks to the exploits of such as *Dr Kildare*, *Bonanza* and *Mr Ed*, the talking horse. Six months later, *The Late Late Show*, hosted by Gay Byrne, was launched and Saturday nights would never be the same again. Exposing ourselves to the world and the

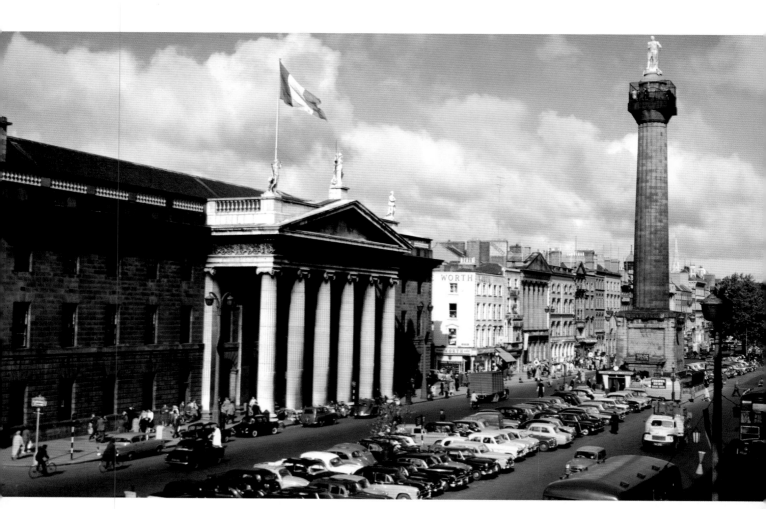

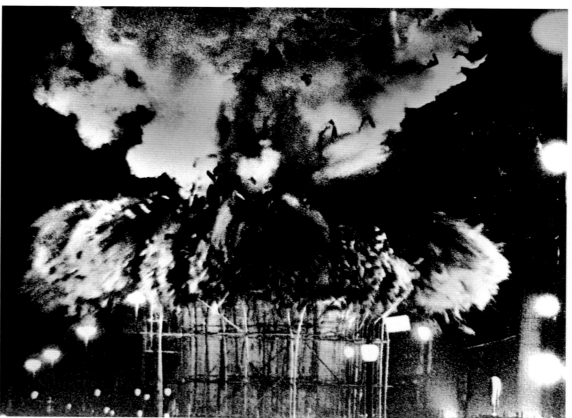

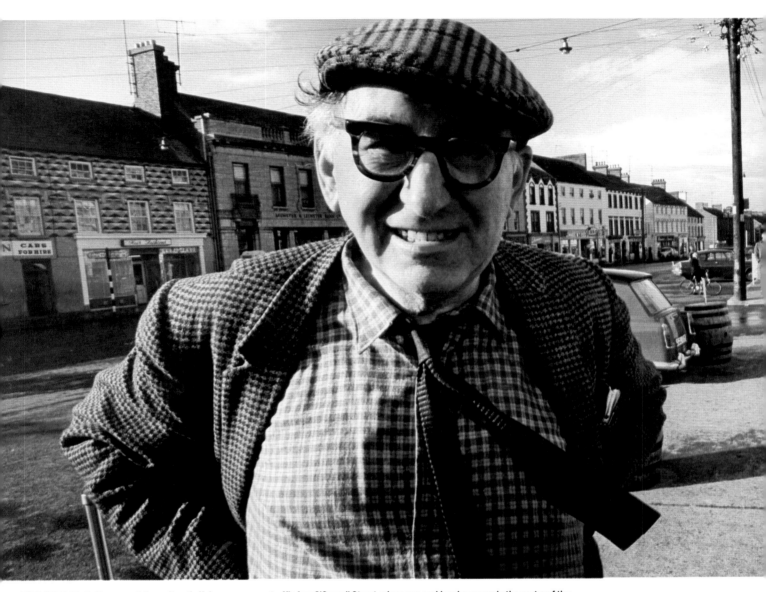

TOP LEFT: Dublin in the rare oul' times. Horatio Nelson oversees a traffic-free O'Connell Street, where you could park your car in the centre of the street – and outside the GPO, if you were stuck!

BOTTOM LEFT: In the small hours of the morning of 8 March 1966, a massive explosion all but demolished Nelson's Pillar in Dublin's O'Connell Street. I was in hospital at the time and was amused on reading the extensive press coverage to see a photo of one of my Finglas pupils emerging from the door in the stump of the column! The army was given the task of removing the stump. Colman Doyle's photo captures the moment of the army's explosion.

ABOVE: *'If ever you go to Dublin town, In a hundred years or so, Inquire for me in Baggot Street, And what I was like to know, O he was a queer one, Fol dol de di do, He was a queer one, I tell you.'* Poet Patrick Kavanagh, pictured in jovial mood not in Baggot Street but on Main Street, Carrickmacross, in his native County Monaghan.

Page 49 :

A pensive study of Micheál Mac Liammóir, actor, writer and theatre-designer. Born in Cork in 1899, he originally toured with Anew McMaster before teaming up with Hilton Edwards to found the Gate Theatre. He also co-founded An Taibhdhearc in Galway. In 1960, he had a major success with his one-man-show, *The Importance of Being Oscar*. His autobiography, *All for Hecuba*, was published in 1946. He died in 1978.

world to our living rooms would be an uneasy process for some. Oliver J. Flanagan TD would later famously declare that 'there was no sex in Ireland before television'.

Major change was happening in the Catholic Church too. The Second Vatican Council, initiated by the much-loved Pope John XXIII, ended in 1965. Although one Irish bishop tried to reassure us that nothing had changed, the Council marked the beginning of an ongoing process of humanising and democratising the Church.

And where was I in the midst of all this brave new world? In 1961 I graduated as a primary teacher and took up a position in the rapidly-expanding new Dublin suburb of Finglas West, a vast development of housing and schools, but with little else in the way of services to cater for the young families who had moved out from inner-city areas. I was young, enthusiastic, dedicated and totally naive. One of my first purchases from my meagre weekly salary of five pounds, ten shillings, was a Bush record player. It was top of the range, purchased in Pim's Department Store for a one-pound deposit and nineteen weekly instalments of a guinea. My father was not impressed by the new-fangled notion of hire-purchase, coming as he did from a generation to whom being in debt was anathema. He went down to Pim's the next day, paid off the debt and said, 'Now you can pay me the weekly instalments!'

That record player became a major part of my life. I built up a classical collection of LPs through the influence of various mentors and of the Sunday-night orchestral concerts at the Gaiety Theatre. There were also the 'singles' and EPs of the pop world which was burgeoning at an extraordinary rate. Four young mop-tops from Liverpool burst upon the music scene and Beatlemania was born. But of course I was a teacher, reserved and detached from all that craziness ...

In America, a young, vital and visionary man had emerged on the political horizon. He was John Fitzgerald Kennedy, of Irish ancestry and the first Roman Catholic president of the United States of America. In his inauguration address he urged his fellow Americans (and fellow world-citizens) to 'ask not what your country can do for you but what you can do for your country.' He was handsome, with a glamorous wife and a magnetic personality. He was the builder of a new Camelot and when the news came in 1963 that he would visit the land of his forefathers, we felt proud and privileged. An American president visiting Ireland! On a brilliant June evening, I stood on O'Connell Bridge amid a happy crowd ten and twenty deep and hailed this dashing, bronzed young champion from the New World. On television we followed his progress around the country, addressing the Oireachtas, charming the crowds in New Ross, drinking tea with his relations in Dunganstown (an American president!) and saying farewell at Shannon with a heartfelt promise to return ...

And six months later, he was dead, felled by an assassin's bullets in Dallas. The grief in Ireland was palpable. He was one of us, after all. It is, I suppose, a cliché to say that

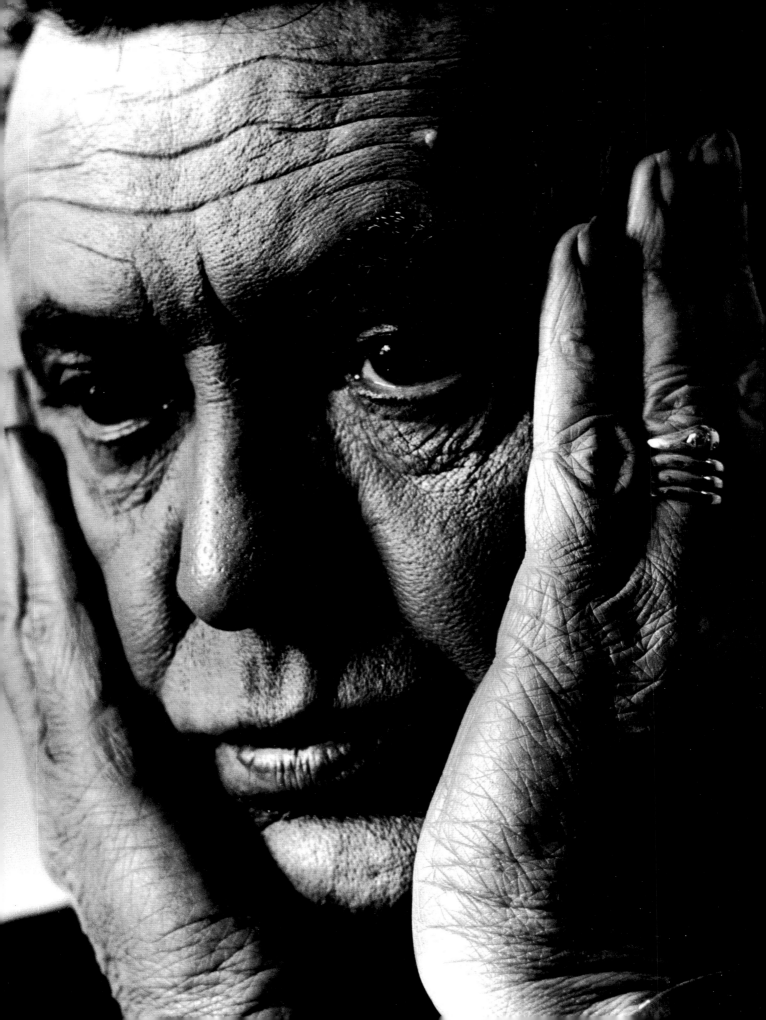

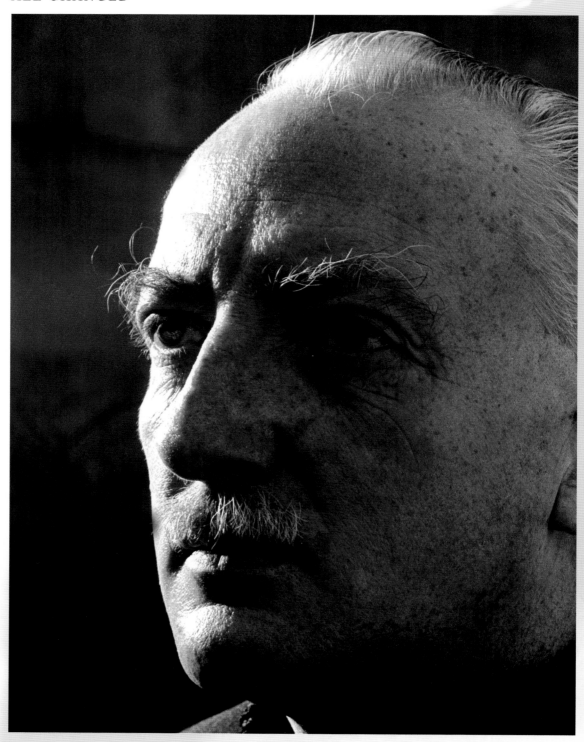

everyone remembers where they were when they heard the news. I recall that I had just come out of a First Arts evening lecture in UCD when a friend informed me as we made our way to an INTO meeting (a particularly acrimonious meeting, as I remember). Trade union matters receded as the reality sank in. We were devastated as we watched the State funeral in grainy television images. Our hero gone. Camelot collapsed. I signed a book of condolence with Tennyson's words:

We will grieve not, rather find
Strength in what remains behind

LEFT: Musician, arranger and composer Seán Ó Riada. Founder of Ceoltóirí Chualann, the first Irish traditional group. Best remembered for his score for the film *Mise Éire* and his three *Ó Riada Masses*.

BELOW: The King of Comedy, still clowning around in his later years. Charlie Chaplin and family were regular Eastertime visitors to County Kerry. Here Charlie is seen with wife Oona on the beach at Waterville.

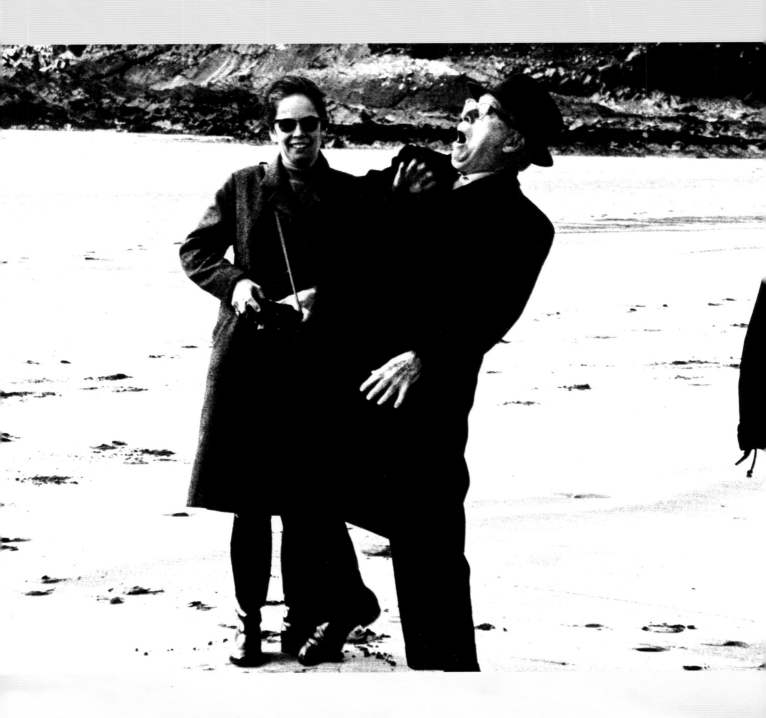

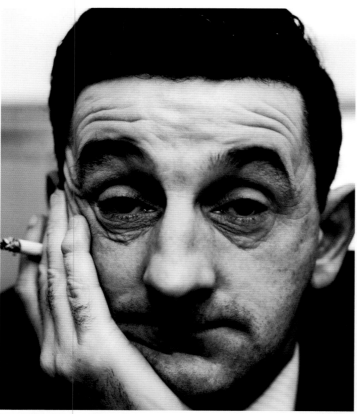

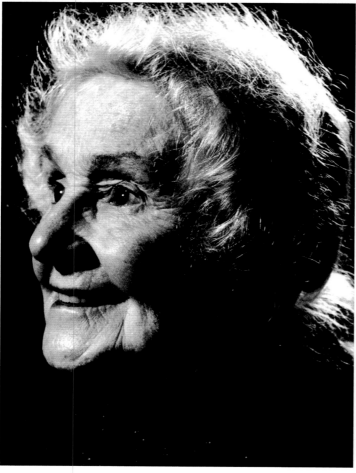

LEFT: Listowel writer John B. Keane, whose many dramas caught the soul of rural Ireland, dealing vibrantly with issues such as exile, repression, land-ownership and religion.

BELOW LEFT: Sinéad, wife of Éamon de Valera. A consummate storyteller, she wrote several volumes of Irish fairytales for children. Here, in old age, she looks the part of a beguiling grandmother from one of her own stories!

Sinéad Bean de Valera died in January 1975 at the age of ninety-six.

BELOW: A midsummer funeral procession in Carraroe, County Galway, 1969.

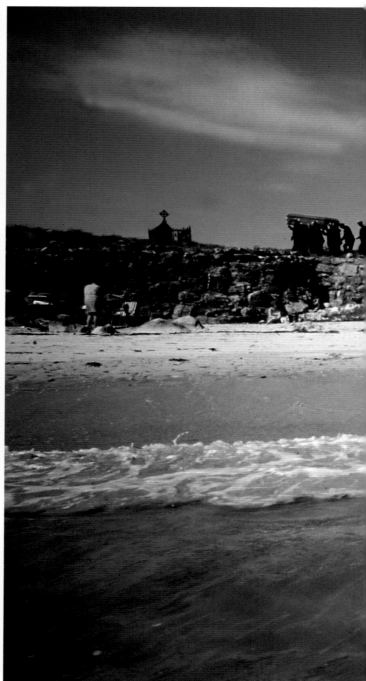

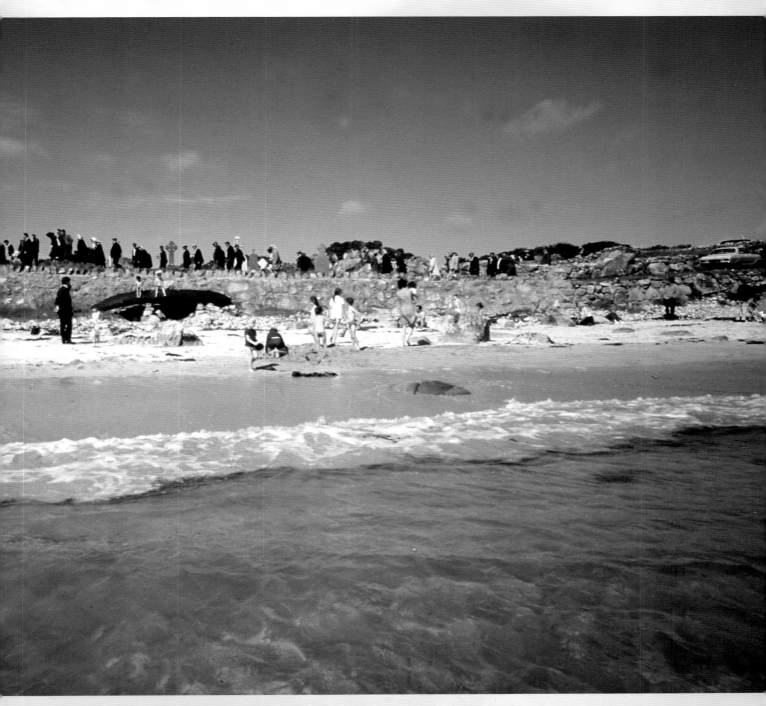

Two years later, I would visit the grave of the fallen chief in Arlington cemetery. It was an emotional moment. I was part of a group of teachers on a five-week study tour of the United States. It was the brainchild of an enterprising teacher, Stephen Daly. We spent three weeks studying American education in New York State University and a further two weeks on tour — Niagara, Detroit, Chicago, Philadelphia and Washington, where we would meet President Johnson and the Kennedy brothers, Bobby and Ted. It was a wonderful, mind-opening experience. The world was indeed growing smaller and travel abroad was eating away at our insularity (the previous year, I had travelled around Italy by train and hitched across Germany and Belgium). Bobby and Ted Kennedy were very different in personality — the older one quiet, serious, introverted, and the younger one boisterous, singing, outgoing. Before the decade was out, fate would deal the Kennedys another blow when Bobby fell victim to an assassin's bullet in 1968.

At the very beginning of the decade, Harold Macmillan, in addressing the South African parliament, spoke the prophetic words:

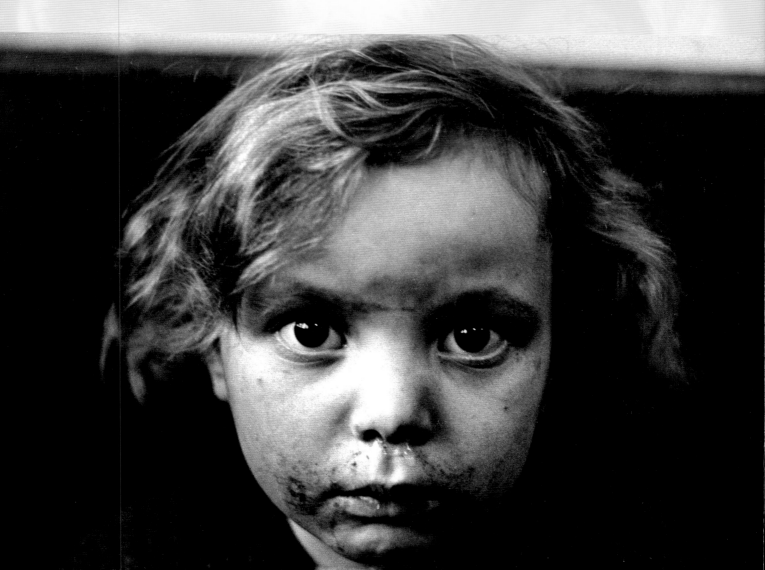

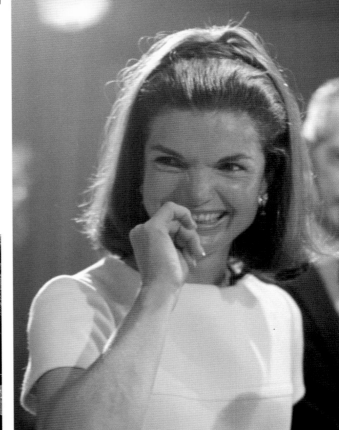

LEFT: Poverty was not unknown in the 1960s. Colman Doyle's study captures the haunting stare of a Dublin city child in 1966.

ABOVE: Princess Grace is welcomed to her ancestral home in County Mayo. It might well be a scene from *The Quiet Man* ...

BELOW: Brendan Corish, leader of the Labour Party, relaxing at Adare, County Limerick.

RIGHT: A happy Jackie Kennedy, snapped on a visit to Woodstown, County Waterford, in 1967.

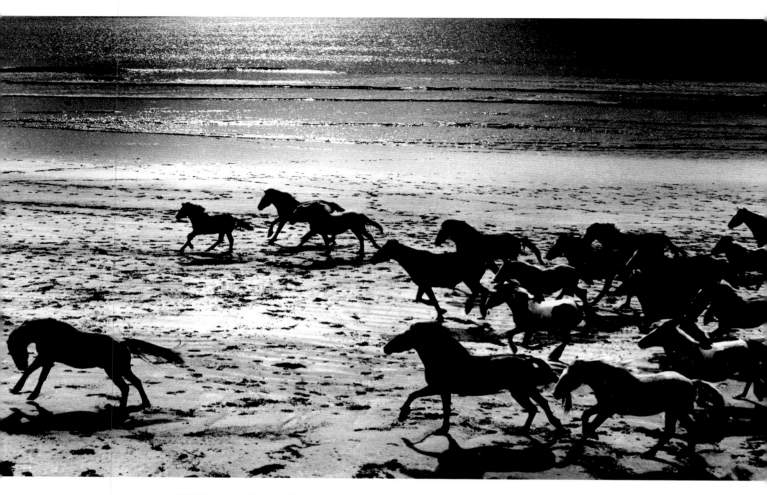

ABOVE: Horse-power! A group of horses captured stretching their limbs on the sunlit beach at Waterville, County Kerry.
RIGHT: An old woman wearing the 'Kinsale cape' in the Cork town.

The wind of change is blowing through this continent and, whether we like it or not, this growth of national consciousness is a political fact.

Six weeks later, Macmillan's host country felt the first icy blast of that wind of change when police opened fire on civil rights protestors in the Sharpeville township and killed fifty-six of them. There was trouble too in the newly independent Congo Republic and our pride in an Irish contingent among the United Nations peacekeeping force turned to grief when nine Irish soldiers were hacked to death in Niemba by Baluba tribesmen. This tragic event gave a new word to everyday speech in Ireland. To describe someone as a 'Baluba' was to heap opprobrium in the extreme on him. I was amazed to hear a young person in recent years use that term (the origin of which he could hardly have known) in describing another youth as 'a bleedin' Baluba'.

* * *

Between my finger and my thumb
The squat pen rests
I'll dig with it

The young Seamus Heaney arrived into the literary world with the publication in 1966 of his first collection, *Death of a Naturalist*. In a 1979 radio interview on his child-hood, he recalled for me his early non-influences – those interminable workbook exercises where you completed similes like 'as strong as __'.

> *The trouble was if you didn't say 'an ox' you were WRONG! There was only one right answer. Likewise with the compositions. You wrote like everyone else. You wrote what you were expected to write. If it was 'A Day at the Seaside' you wrote: 'My mother bought me a bucket and spade and I played happily in the sand ...' Well, my mother bought me a wooden spoon and let me foother around in the sand. I never knew you could tell the truth until I was about twenty-one and in a way that's why I started writing ...*
>
> ('I Remember, I Remember')

A lot of squat pens were taken up in the 1960s to 'tell the truth'. An extraordinary literary flowering took place. Apart from Heaney, there was a positive blossoming of poets such as John Montague, Patrick Kavanagh, Thomas Kinsella, Richard Murphy, Brendan Kennelly, Eavan Boland, Seán Ó Riordáin and Máirtín Ó Direáin. The truth

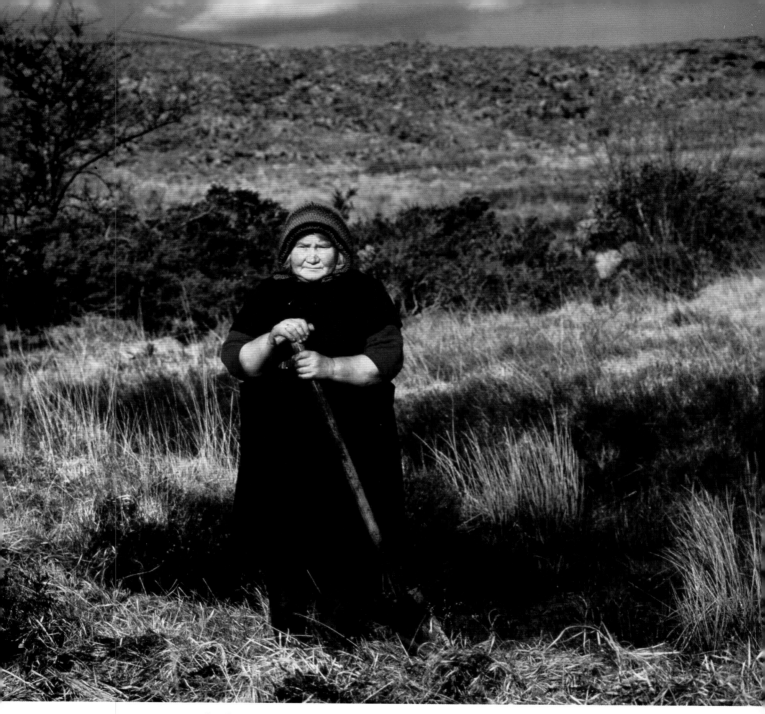

was also being told on the stage through such works as John B. Keane's *Sive* and *The Field*, Hugh Leonard's *Stephen D*, Tom Murphy's *A Whistle in the Dark* and Brian Friel's *Philadelphia, Here I Come*. The latter work thrilled me so much when I saw it in the Gate Theatre that I felt I had to share it with second-level students I taught in a County Sligo school a few years later. They were equally spellbound by the play (this was long before it was officially promoted to the school syllabus). Over thirty years later, when I attended a reunion to mark the closing of the same school, those same students, now in middle age, recalled that Friel's play was their abiding memory of their classroom days.

Some writers would of course pay a heavy price for telling the truth. As already mentioned, Edna O'Brien incurred the wrath of the Censorship Board. Worse was to happen to another novelist, a young teacher from County Leitrim who had come to prominence with the publication of his first novel *The Barracks*. But when John

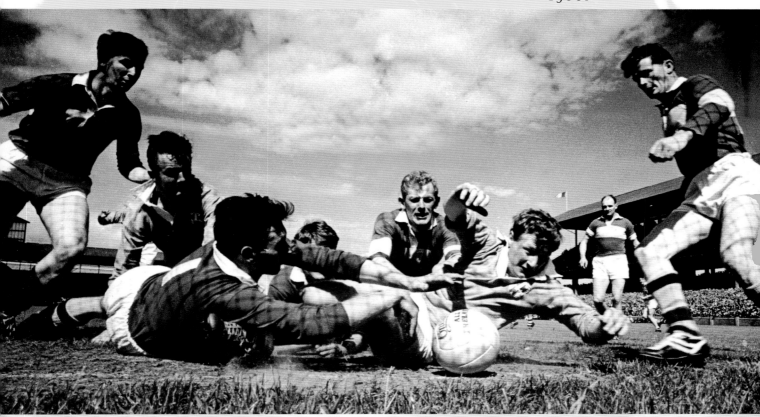

LEFT: A Donegal woman working on the bog.

ABOVE: A goalmouth scramble during a 1965 semi-final clash between Kerry and Dublin. Final score: Kerry 4–8, Dublin 2–6.

McGahern's second work, *The Dark*, was banned, he was also banned from his teaching position in Clontarf, Dublin. He recalled the event for me in a 1996 radio interview:

There was enormous pressure on me to be the decent fellow and resign. I was determined that I wasn't going to do that ... When I turned up at the school everyone was in a worse state than I was and we made endless cups of tea that morning. The headmaster was in an awful state. He had informed me that I wasn't allowed into the classroom ... The parish priest told me he was very happy with me (as a teacher) and why did I have to go and write that book and bring all this trouble down on him. He told me he had nothing against me but that the Archbishop, John Charles McQuaid, had told him to fire me.

('My Education')

How ironic that, amid all the literary light that was being shed on the Ireland of the 1960s, a book entitled *The Dark* should engender such a scandal.

For all the literary flowering of the 1960s, however, the decade also took its toll on some of the giants of Irish literature. The year 1964 was a particularly bad one. Two dramatists — Brendan Behan and Sean O'Casey — each controversial in his day, died within six months of each other. Maurice Walsh, whose *Quiet Man* became a classic 1950s film. Pádraig Ó Siochfhradha — An Seabhac — whose *An Baile Seo 'Gainne* we had struggled with at school. And on the last day of that year, we lost Daniel Corkery, author of that great study of Gaelic culture, *The Hidden Ireland*. The year 1966 stole the master of the short story, Frank O'Connor, from us and a year later we lost the raucous genius from

the wee hills of Monaghan, Patrick Kavanagh. I had and have a great affection for Kavanagh's poetry. My father had come from those same wee hills and on many childhood visits to Monaghan I too was 'king of banks and stones and every blooming thing'. Kavanagh went on to leave country life behind him and embrace the city where he died on 30 November 1967.

> *O commemorate me with no hero-courageous*
> *Tomb – just a canal-bank seat for the passer-by*

* * *

In November 1965, just three months after my sojourn in the USA, a significant event occurred in my life.

BELOW: Between a rock and a hard place ... Carraroe, County Galway.
RIGHT: The wild Atlantic batters the Aran islands.
Pages 62–63:
LEFT: A blacksmith at work outside his forge at Lahinch, County Clare.
RIGHT: A fun day out. Two nuns (how young they are!) share a laugh with one of their charges, having brought children from an orphanage on a day-trip to the seaside.

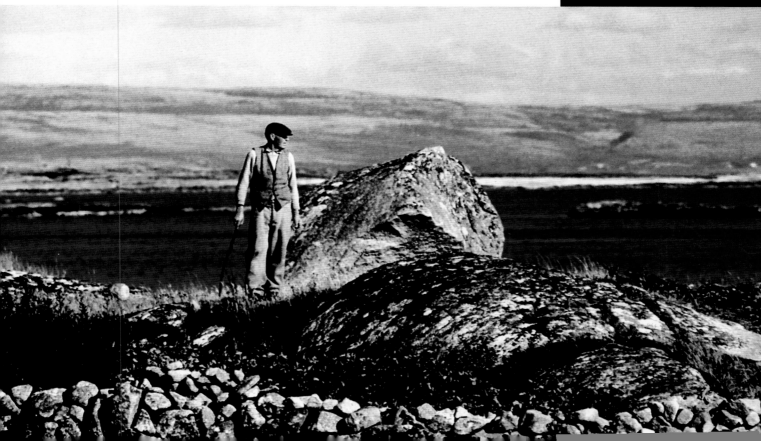

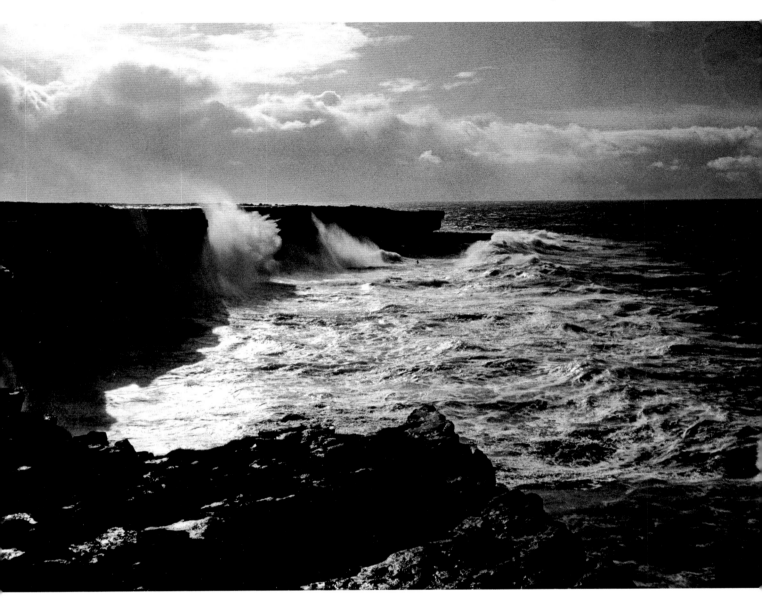

Initially traumatic, it turned out to be life-changing. I was diagnosed, following a visit to the Mobile Mass X-Ray Unit, as having tuberculosis of the lung. TB — the scourge of the nation's health in the 1930s, 1940s and 1950s, so much so that its name was unspoken. It was referred to as 'the weakness', 'being delicate' or at best 'consumption'. Although it had been seriously tackled by the introduction of drugs such as streptomycin and the building of sanatoria, it was still rife in the mid-1960s. (Dr Noel Browne, the Minister for Health who was the driving force behind the building of the sanatoria, was given the ultimate accolade by a Dublin slum dweller: 'God bless Noel Browne — the man that gave us the free TB.')

When I entered Blanchardstown Sanatorium ('the Blanch' to its inmates) on a raw November afternoon for a nine-month 'sentence' of rest and medication, I was but one of five-hundred-plus TB patients scattered throughout the wooded estate in isolated 'units' and a hospital building. I have always considered my sojourn in 'the Blanch' to be a major part of my education. For a raw, callow young fellow to be cast among a col-lection of the charming and the cantankerous, young blades and hardened 'chaws', the

wise and the world-weary, and to live in close proximity with them for nine months —
it could not be other than a real education. And then, thanks to Arkle, something
magical happened on 1 March 1966.

The magnificent steeplechaser, Arkle, and his jockey, Pat Taaffe, were the sporting
icons of the 1960s, winning three successive Cheltenham Gold Cup victories. There
were unforgettable duels with his great rival, Mill House. Little wonder that, as Colman
Doyle's picture (p. 64) shows, he would be paraded for public adulation at the Dublin
Horse Show. Little wonder also that, on 1 March 1966, on a visit to the hospital build-
ing for a routine test, I should be anxiously searching for a radio to hear commentary
on Arkle's victory in the Leopardstown Chase. In my frantic search I caught a brief but
sufficient glimpse of a 'vision in a black leather coat'. An elegant, stunningly beautiful
woman. A fellow-patient. Her name was Olive McKeever, and suddenly there was more
to life than Arkle.

Although we 'lived' only a field apart in separate, segregated units, we could initially
communicate only by letters, 'smuggled' to and fro by obliging hospital staff (shades of
boarding school of the 1950s!) For six weeks we corresponded — wonderful, wonderful

letters in which we slowly unfolded our personalities and our growing affection for each other. We did not meet until Easter Sunday and subsequent rendezvous (especially a daring bank-holiday ramble in the woods which incurred the wrath of officialdom) only confirmed what I knew on that first afternoon in March. For us, the summer of 1967 was truly the summer of love and in short, reader, I married her in September 1968. So God bless Arkle, God bless Noel Browne, God bless TB and God bless Olive McKeever, my life-partner until she died rather suddenly on 25 June 2001. As I often – but not often enough – told her, my real date of birth was 1 March 1966.

I resumed teaching in Finglas in September 1966. It was an interesting time to be involved in education. 'Investment in Education', the report of a survey of Ireland's educational needs, had just been published. The survey's director was the economist Patrick Lynch, a greatly influential thinker who helped shape our modern economy along with people like Ken Whitaker.

Patrick Lynch was a very self-effacing man, who preferred to pay tribute to others. He was particularly impressed by the then Minister for Education, Patrick Hillery – 'one of the most thoughtful people I have come across ...'

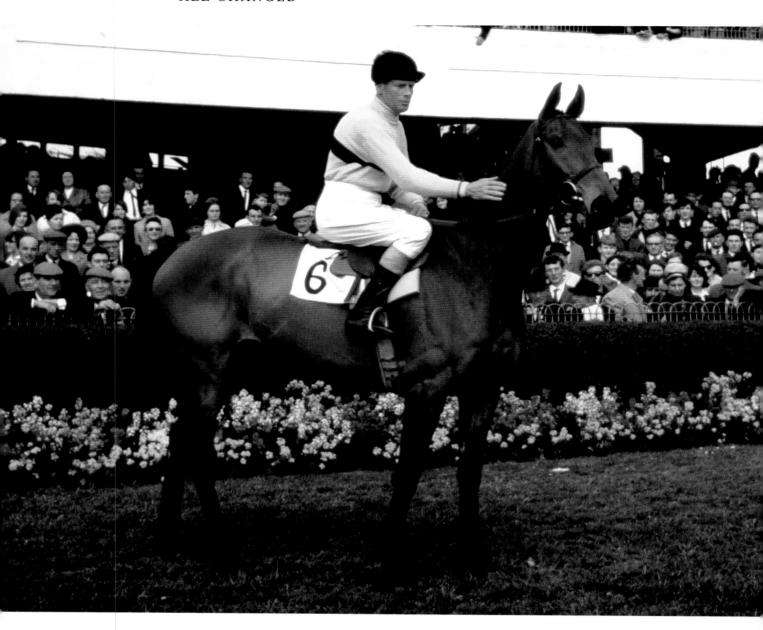

He used to discuss the project that we were engaged on, but he very rarely made a direct contribution. He confined himself to asking a very awkward question, with the result that one went away and spent the next week thinking out the implications of that question …

('My Education')

In the same week that I resumed teaching, three comprehensive schools were opened — at Carraroe, County Galway; Shannon, County Clare, and Cootehill, County Cavan. A few days later came an even more significant development. A new minister held the education portfolio. The ebullient Donogh O'Malley announced that free post-primary education would be available to all from 1967 onwards. A bold move, but many of us wondered whether it would be logistically feasible in that timescale. I had a personal interest in the situation as I was preparing a scholarship class in Finglas West

(scholarships being the only avenue to post-primary education for most Finglas children). O'Malley's thinking seemed to be ahead of that of Dublin Corporation which was still advertising scholarships for 1967. Confused, I wrote in high dudgeon to the *Irish Times* asking if someone would clear the air, 'or are there too many castles up there already?'

The air was cleared eventually and the scheme was rolled out on schedule. Soon the yellow *bus scoile* would be a familiar sight on country roads, bringing access to secondary education to a whole new generation. I imagine Donogh O'Malley must have been a civil servant's nightmare. He seemed to think on his feet, announce a plan and leave the worry of its implementation to others. In 1967, he announced his intention of merging Trinity College and UCD into one University of Dublin. It was never going to happen and the plan was ultimately abandoned. In the same year, O'Malley abolished the Primary Certificate Examination. He was a doer, bristling with energy, but sadly his time was short. He died on 10 March 1968, at the age of forty-seven. Before the decade ended, another significant development in education occurred. In September 1969, the first Regional Technical Colleges, first mooted in 1963 by Patrick Hillery, were opened at Athlone, Carlow, Dundalk, Sligo and Waterford. They would address the

LEFT: Champions on parade. The mighty and mightily popular Arkle, winner of three successive Cheltenham Gold Cups (1964–66), goes on parade at the RDS Dublin Horse Show in 1966. On board, his equally popular pilot, Pat Taaffe.
BELOW: The other end of the horse-racing spectrum. A 'farmers'' race on the strand at Louisburgh, County Mayo.

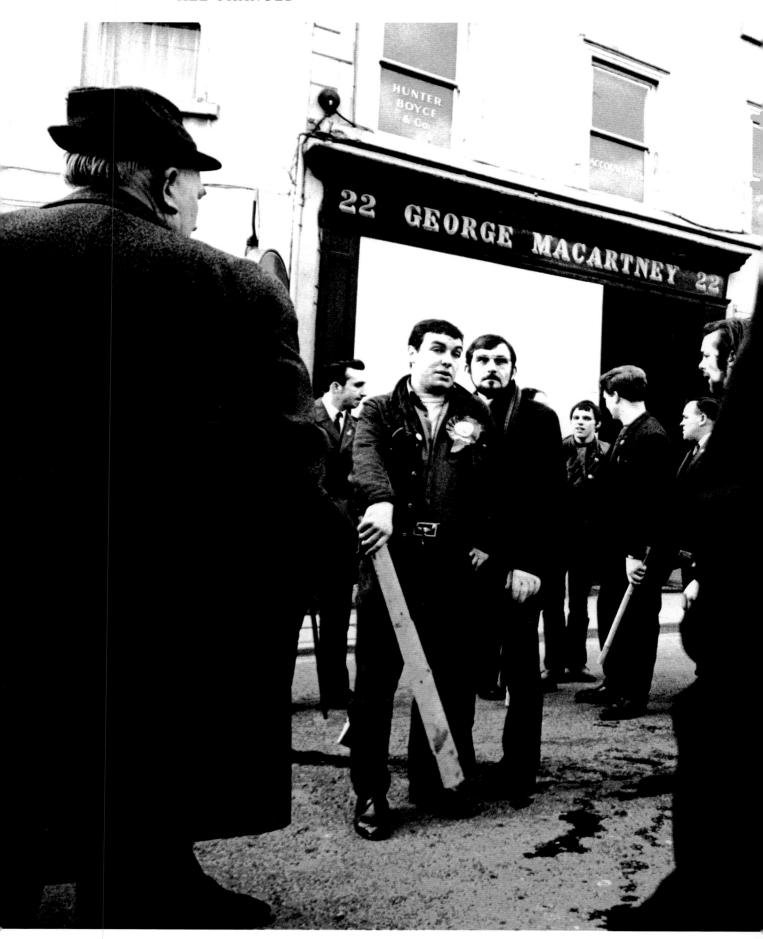

technological imbalance of the education system and would subsequently become the Institutes of Technology that offer high-quality third-level education today.

* * *

'What is the stars? ... What is the moon?' These were 'Darlin' questions' that Captain Boyle had mused over in O'Casey's *Juno and the Paycock*. The musing was over as we entered the 1960s. The Russian–American 'space-race' was on in earnest, the Russians having got a headstart in 1957 with the successful launch of the satellite *Sputnik*. They went further ahead in 1961 when Yuri Gagarin became the first man in space, albeit for a mere 108 minutes. The Americans hit back a year later when John Glenn spent five hours in orbit. In that same year, 1962, the *Telstar* satellite beamed live television pictures across the Atlantic for the first time. The world was indeed shrinking into a global village. The stuff of science fiction finally became fact, however, on 21 July 1969, when Neil Armstrong took his one small step onto the surface of the moon. I was visiting my father-in-law in hospital that day with my pregnant wife. When he was born, the motor-car had not yet appeared on our roads. What wonders would unfold for our soon-to-be-born daughter in her lifetime?

Back down on Planet Earth little heed was being paid to the 'make love, not war' plea of honeymooners John Lennon and Yoko Ono. The world was, in O'Casey's immortal phrase, 'in a state of chassis' – Martin Luther King and Bobby Kennedy assassinated within months of each other in 1968; race riots across the USA; student revolt in France; a Russian invasion of Prague where a young student, Jan Palach, made the ultimate heroic protest of self-immolation; a six-day war between Israel and Arab states; the Americans sucked deeper into an horrific war in Vietnam, despite increasing protests at home. And for the first time, television pictures from Africa brought into our homes the disturbing images of famine resulting from the conflict between Nigeria and its break-away state, Biafra. Meanwhile, Louis Armstrong sang 'What a Wonderful World' …

LEFT: Not an inch – further. A civil rights march in Armagh is confronted by Paisleyites, brandishing assorted 'weapons' …

Pages 68–69:

LEFT: A young Ian Paisley, photographed in 1968.

TOP RIGHT: The Battle of the Bogside. Barricades have been assembled to keep the police out of 'Free Derry'. The police reply with CS gas.

BOTTOM RIGHT: The Battle of the Bogside. Does 'Business as Usual' refer to the Fashion Centre or to the notorious 'B' Specials – a part-time reserve force within the RUC? Here they wear handkerchiefs as protection against CS gas and they wield pickaxe handles, 'officially' issued to combat the hurleys used by nationalists. Later, in 1969, the Hunt Report on policing in Northern Ireland recommended the disbandment of the 'B' Specials, much to the fury of loyalists.

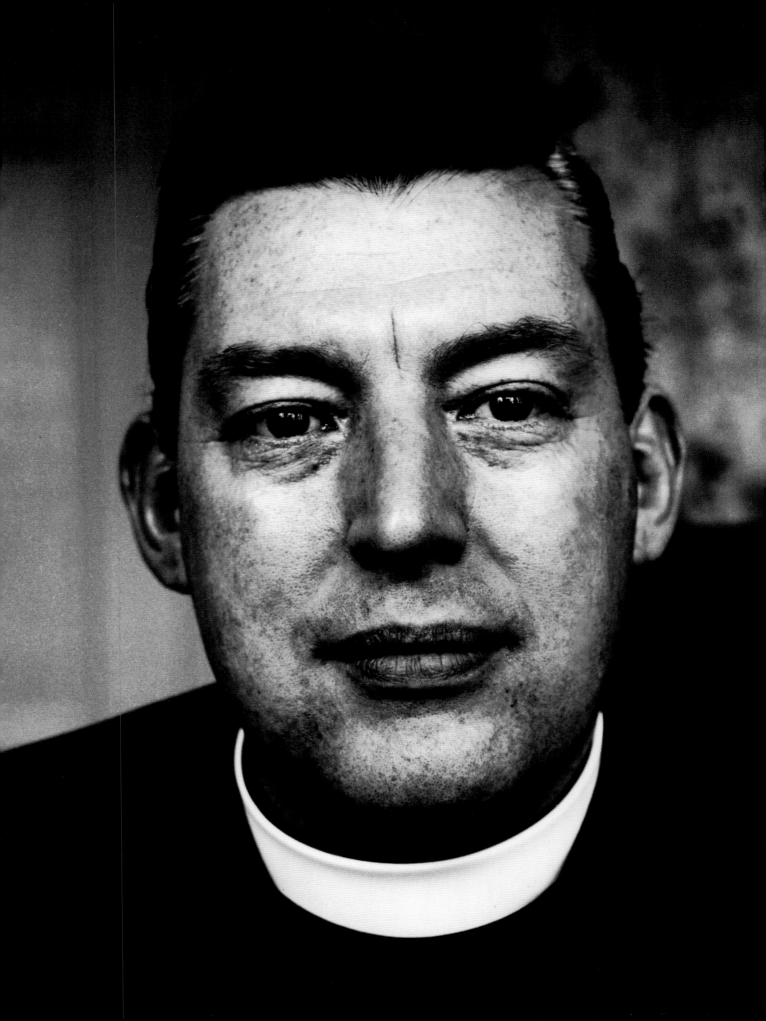

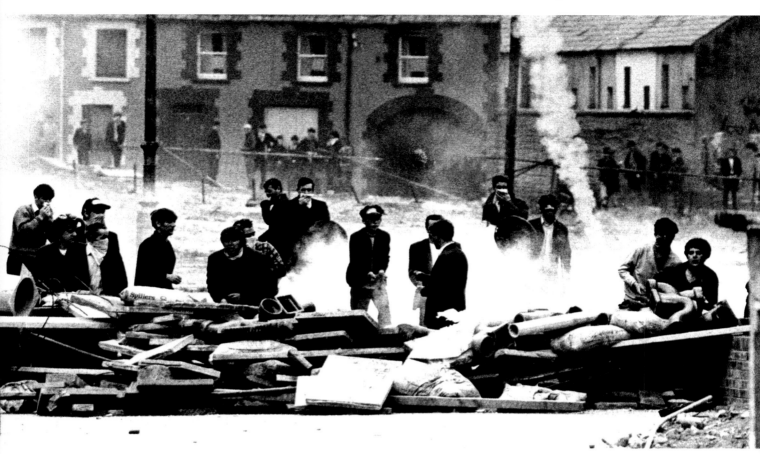

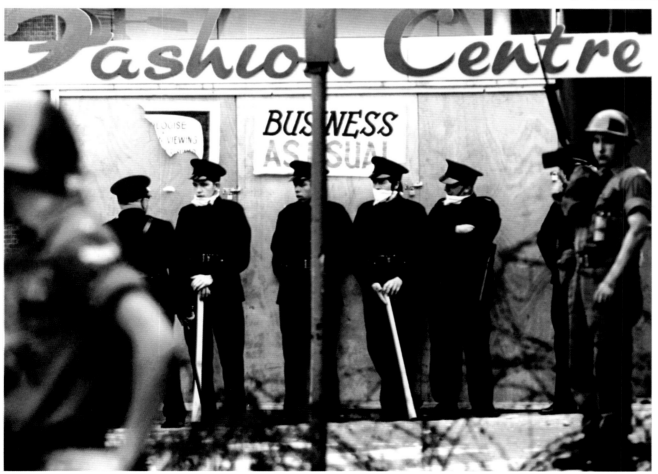

BELOW: John Hume at Free Derry Corner: 'Let the world see who the real aggressor is ...'
RIGHT: A bowler hat and 'the sash me father wore'. An Orangeman on parade, Derry 1969.

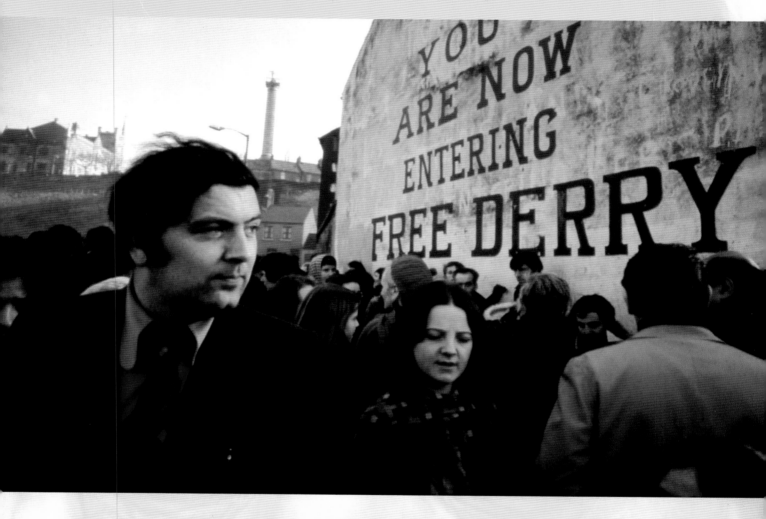

Gerry Fitt, who had lived through forty of those years of misery, later told me:

The Civil Rights Movement was totally justified, but it scared the life out of the Protestants. They saw it as an attack on their privileges, which it wasn't. And that began the trouble ... There was awful fear in West Belfast. The Catholics thought they were going to get slaughtered in their beds. I telephoned Jim Callaghan, the then Home Secretary, and pleaded with him to send the army in, because there was a real fear that a pogrom could have broken out in Northern Ireland. I remember what he said to me: 'Gerry, I can get the army in, but it's going to be a devil of a job getting it out.' And how right he was proved to be.

('My Education')

The 'Troubles' had begun.

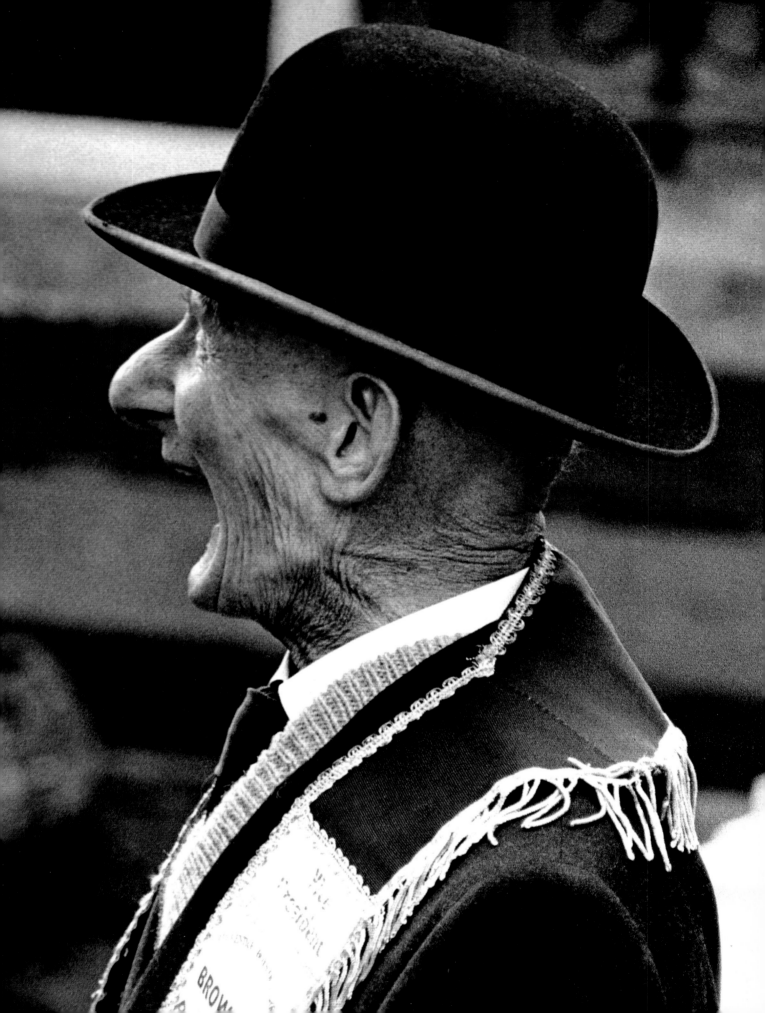

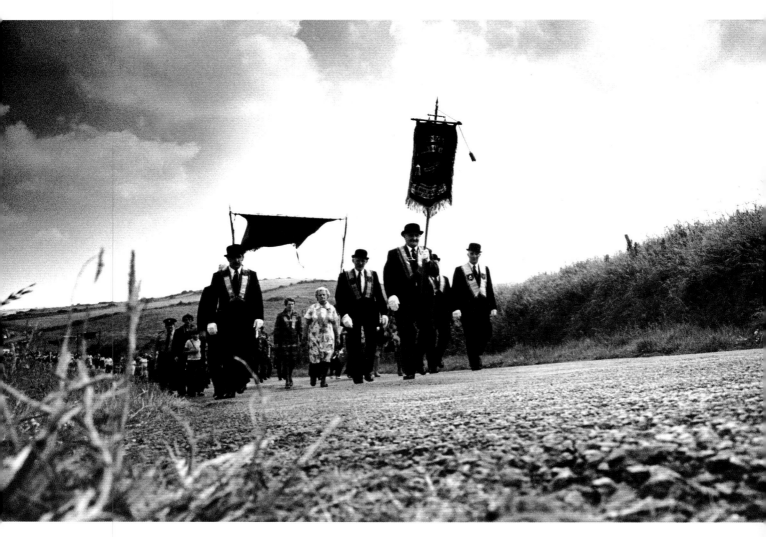

ABOVE: On the way to 'the field'. Orangemen and women step it out proudly on their way to a Twelfth of July rally. This particular parade is, unusually, outside the 'wee six' (counties) – in Rossnowlagh, County Donegal.

and flaring petrol bombs
the blunt, squat shape of
an armoured car glides
into the narrow streets
Of the Catholic quarter
leading a file of helmeted,
shielded riot police;
Once again, it happens,
like an old Troubles film,
run for the last time.

(John Montague, 'A New Siege')

1970s

t was a bloody, bloody decade. There are no other words and no adequate words to describe it. Bloody Sunday, the Abercorn, McGurk's Bar, Bloody Friday, Claudy, the Miami Murders, La Mon, the Dublin-Monaghan bombs, Mountbatten, Warrenpoint, Ewart-Biggs, Birmingham — a seemingly endless bloody litany.

And those are only some of the front-page events. Threaded through that litany are the individual victims, the innocent bystanders, almost insignificant to us but real, living, searing memories to the families from whose hearts they were cruelly, savagely ripped. A First Communion photograph of shining innocence; a smiling souvenir of wedding-day bliss; a loving, loved grandmother; a shy farmer, a countryman loath to pose for a camera — they sit there enshrined on mantelpieces across a dark and divided landscape. Taigs, Prods, Brits, volunteers, loyalists. Hatred, horror, hopelessness.

Looking back through the prism of thirty years' hindsight causes me to shudder. Did we really live through such horror, we who were (fairly) comfortably distant 'down here', away from the vortex of all that violence? How did they 'up there' live through the reality of it all? How much did we really care? How much did they really suffer? Of course the reality is that over 3,000 of them did not live through it all. They continue to smile from thousands of mantelpieces. It was just a bloody, bloody decade.

On a personal note, the decade started brightly for me. Now teaching in Navan, married and with a baby daughter. In February 1970, the Quinn family moved into a newly built bungalow on the outskirts of Navan. The cost is imprinted on my memory — four thousand, seven hundred and seventy-five pounds. And I didn't have one of those pounds to spare. So I faced into the 1970s with wife, daughter and sizeable mortgage. A few weeks later, the horizon brightened considerably when I was approached by CJ Fallon Ltd., educational publishers, and was offered the position of general editor. The job carried an annual salary of £2,000. Considering that my teacher's salary was then £1,100 per annum, I was more than happy to accept the offer. It was a challenging and enjoyable job. Change was happening in education — a new, child-centred curriculum was introduced into primary schools with new methodologies and new subjects such as Environmental Studies, Art and Crafts, Civics and 'New' Mathematics.

Working in Dublin and living in Navan meant (reasonably) long-distance commuting — a common feature of twenty-first-century life but novel enough in the 1970s. But then, as a popular commercial has often reminded us, Navan was 'only an hour from Dublin'. Fine, until the oil-producing countries put the squeeze on the West and we were faced with petrol shortages, long queues and another new concept — car-pooling.

Belfast Republican Joe Cahill. Sentenced to death in the 1940s for the murder of a policeman, he later became Chief of Staff of the IRA. Cahill was jailed in 1973, following his arrest on the gun-running ship *Claudia*.

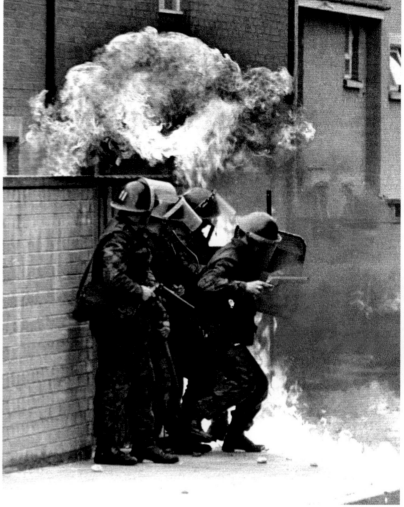

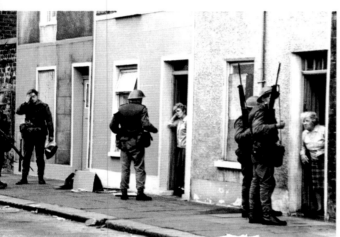

The great running story of the opening year of the decade was what became known as the Arms Crisis and subsequently the Arms Trial. Following the 'Battle of the Bogside' in 1969, an Taoiseach Jack Lynch said in a television address to the nation that it was clear:

that the Irish government can no longer stand by and see innocent people injured and perhaps worse ...

The 'worse' would come in the next two days when rioting in Derry and Belfast ended with several fatalities. Lynch called for a United Nations peacekeeping force to enter Northern Ireland and ordered the Irish Army to set up field hospitals along the border to treat casualties of Northern violence. There would be no UN force, but British troops were sent in to keep the peace and were initially welcomed by the Catholic community. The British Secretary for Defence, Denis Healey, claimed: 'We are preventing a civil war.'

Less than two weeks into the new decade, the Provisional IRA came into being and began a military campaign against the British Army which would last for almost three decades. In May 1970 came the thunderbolt. Lynch sacked his Minister for Finance, Charles J. Haughey, and his Minister for Agriculture, Neil Blaney. Another minister, Kevin Boland, resigned in sympathy. Haughey and Blaney were subsequently arrested

OPPOSITE LEFT: Troops carry out door-to-door searches for weapons during the Falls curfew of July 1970, Belfast.

OPPOSITE RIGHT: Troops recoil as a petrol bomb explodes, Derry city.

THIS PAGE: The bloody streets of a bloody decade – Bloody Sunday, Derry, 1972.

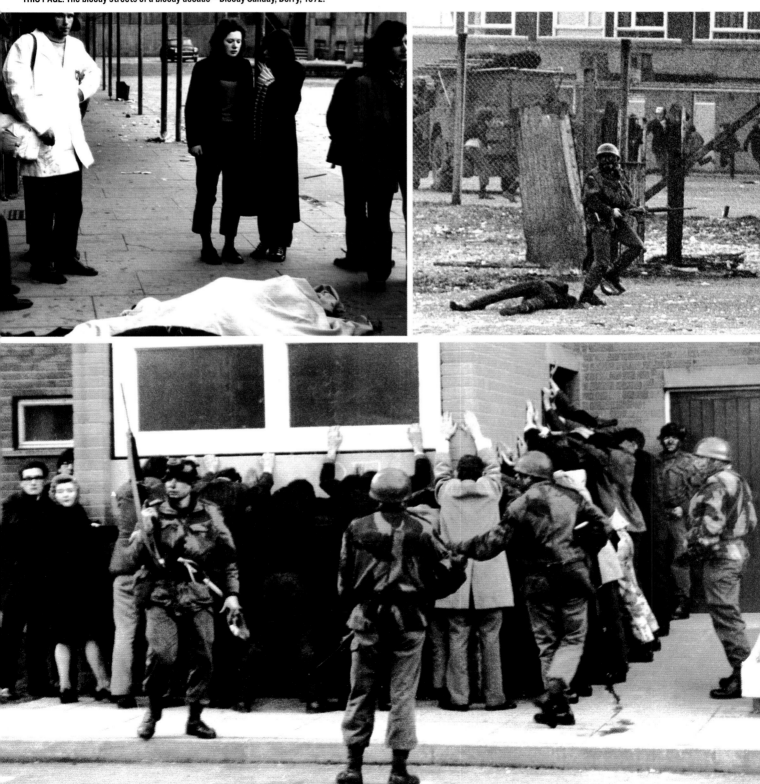

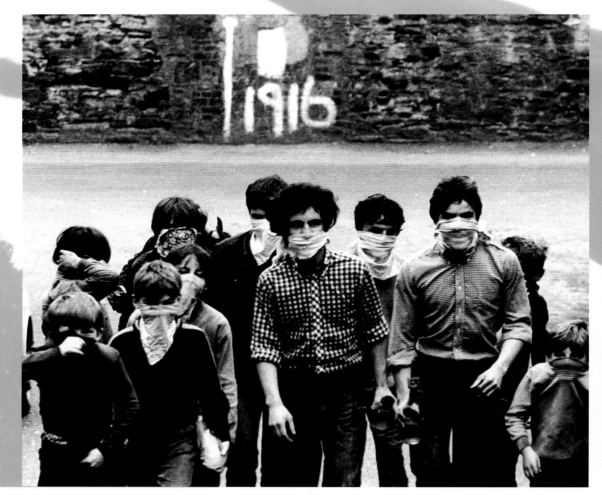

ABOVE AND TOP RIGHT: Internment without trial, introduced in 1971, led to protests in Derry (armed with petrol bombs) and (top right) in Belfast.
BOTTOM RIGHT: A woman IRA volunteer on active service in West Belfast with an AR18 assault rifle. A minority of women broke away from Cumann na mBan, wanting to play a more active role in the 'armed struggle'.

and charged, along with an Army officer, Captain James Kelly, and a Belgian business-man, Albert Lukyx, with conspiring to import arms, allegedly for the use of the Provisional IRA. After two trials, all four were eventually acquitted. The whole affair is still clouded in mystery but it was sensational stuff. There were charges and counter-charges during a marathon Dáil debate before the Government renounced the use of force to resolve 'the northern problem'.

They were uneasy times. The Arms Trial overshadowed the visit of US President Nixon, who came in search of his Quaker roots. The 'northern problem' was growing more acute by the day. Our television screens and newspapers expanded their coverage dramatically and a whole new language unfolded — curfew, house-to-house searches, rubber bullets, Provo bombs, unapproved roads, CS gas, refugees and, in August 1971, a phrase which exacerbated the entire situation: 'internment without trial'. Almost sur-really in the midst of all the mayhem, in March 1970, Rosemary Brown, a wee teenaged girl from Derry, singing sweetly and innocently about 'snowdrops and daffodils, butterflies and bees', won the Eurovision Song Contest with 'All Kinds of Everything'. All kinds of everything, indeed.

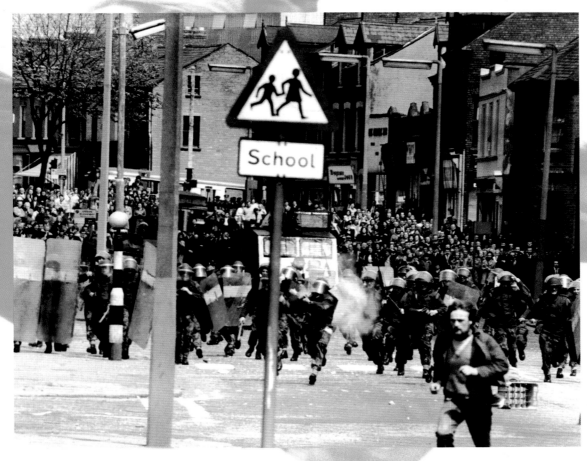

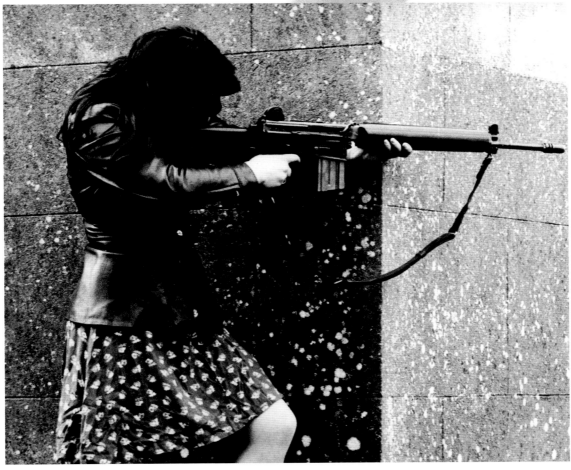

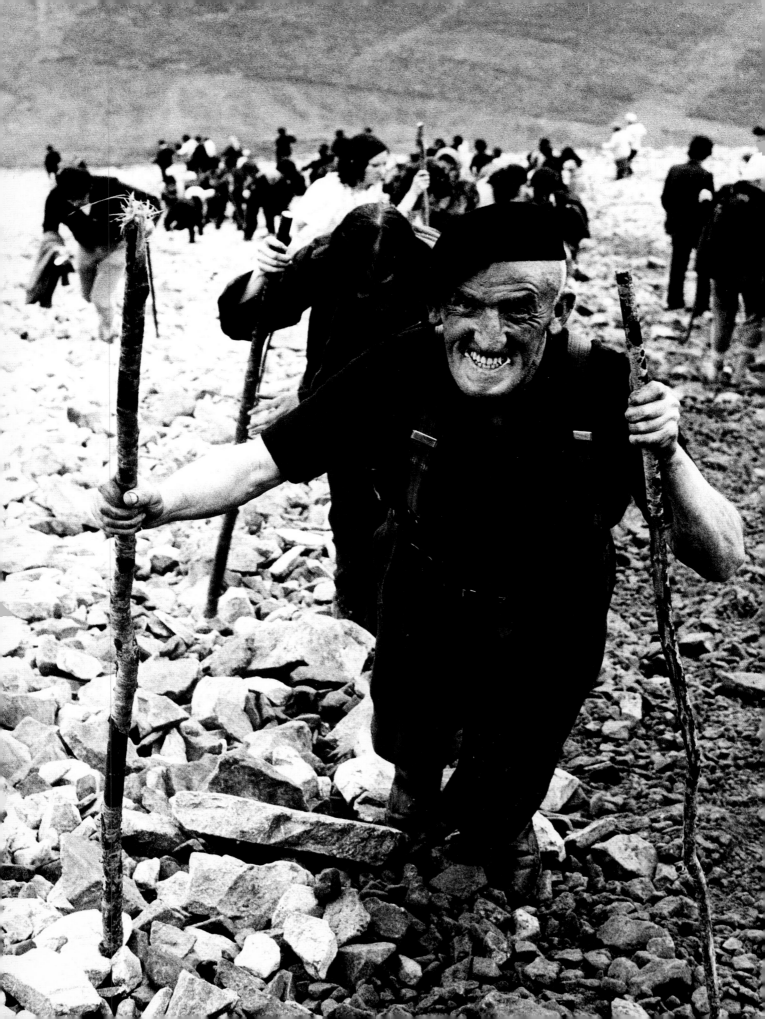

LEFT: Climbing the Reek – Croagh Patrick, County Mayo.
BELOW: Poitín raid, County Galway.
Pages 84–85:
LEFT: As if we didn't have enough bloodshed ... cockfight, County Monaghan, 1978.
TOP RIGHT: Arthur Ó Flaithearta competes in the long jump during the *patrún*, Inis Mór, Aran islands, 1976.
BOTTOM RIGHT: Woman of Aran.

The Arms Crisis in May of 1970 overshadowed all else in the way of news, but not — for me anyway — one small item. On 31 May, my old friend Arkle had to be put down. God Bless Arkle.

It wasn't all darkness and doom, of course. Life goes on. Fashions changed. Tight short shorts and long bushy hair were in vogue — on the football field! And moustaches! Images of Steve Heighway flying down the wing for Liverpool in their glory days. On the Gaelic football pitch, the decade was dominated by the great Dublin–Kerry rivalry. The classic confrontation — the 'Dubs', the 'Jacks', the city slickers versus the 'cute hoors', the mountainy men from the Kingdom carrying the banner for rural Ireland. The pendulum of power swung both ways: Dublin champions in 1974, Kerry in '75, Dublin in '76 and '77 and Kerry from '78 to '81, until they were sensationally deprived of the magical five-in-a-row by Offaly in 1982. Two astute managers, Kevin Heffernan and Mick O'Dwyer, pitted against each other. Epic contests involving stars like Kevin Moran, Brian Mullins, and Jimmy Keaveney for Dublin doing battle with

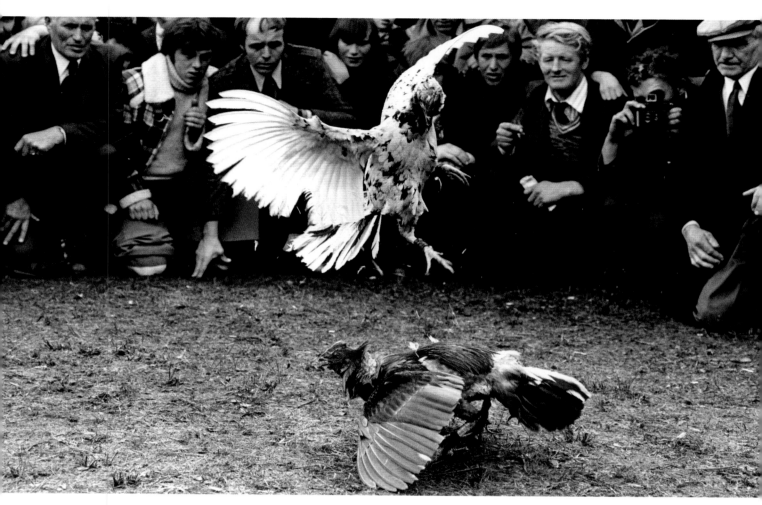

Jack O'Shea, Pat Spillane and John Egan from Kerry. Memorable stuff.

On the dance-floor, fashions were changing too. The Showband years were giving way to a newly manufactured craze – disco-dancing under flashing lights in the regulation gear: flared trousers, and long bushy hair of course. The Beatles had become history and no, they wouldn't be getting together again. 'You can't reheat a soufflé,' Paul McCartney declared.

Two very different kings of popular music died within months of each other in 1977. The real King, Elvis Presley, died (allegedly, or was he just 'taking a break'?) at the age of forty-two, while the 'Old Groaner', Bing Crosby, died, as he would no doubt have wished, on a Spanish golf course. On television we were captivated by the goings-on in *Upstairs, Downstairs* and maybe a little bemused by the comedy antics of the Monty Python team. Maureen Potter was blowing *Gaels of Laughter*. Life went on. We laughed, we danced, we sang, but the pall of darkness still hung over Northern Ireland.

The year 1972 was a particularly dark one. A bloody prelude had occurred in the previous December when 'Empire Loyalists' killed fifteen with a bomb in McGurk's Bar in Belfast. And 28 January was etched into history as 'Bloody Sunday', when soldiers of the First Parachute Regiment opened fire on a banned civil rights march in Derry, killing thirteen – a 'butcher's dozen', as Thomas Kinsella described the slaughter in a commemorative poem. A few days later, on a national day of mourning, protestors

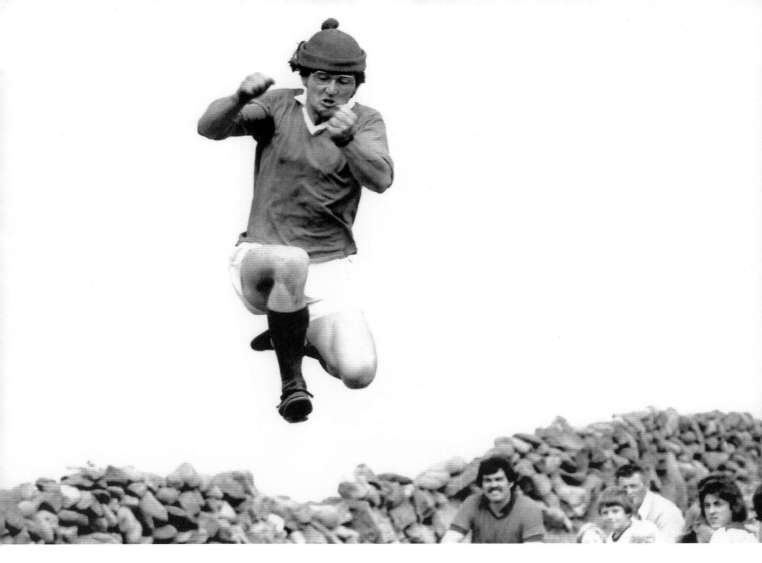

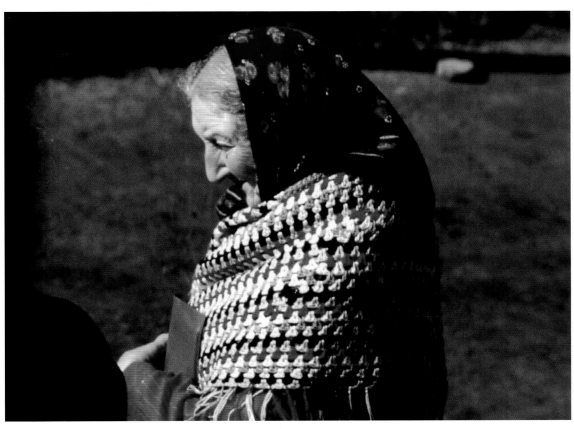

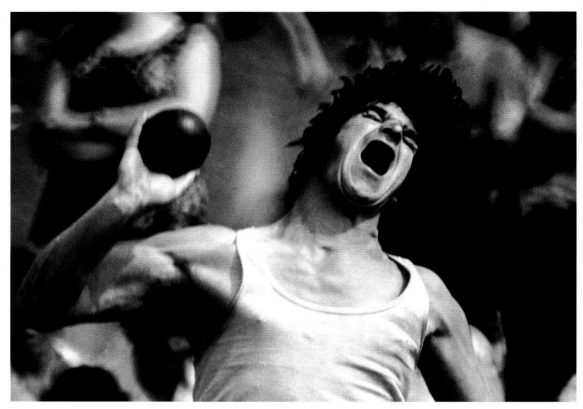

ABOVE: Bartley Walsh putting the shot at the Inis Mór *patrún*.
OPPOSITE: Liam Cosgrave TD, leader of Fine Gael 1965-77, Taoiseach 1973-77.

burned down the British Embassy in Merrion Square, Dublin.

Dark, fearful times. The Scottish and Welsh rugby teams refused to travel to Ireland. The violence continued relentlessly. Murder and mayhem in the crowded Abercorn restaurant; Bloody Friday in July when twenty-two Provisional IRA bombs killed eleven and injured hundreds in Belfast; three car-bombs ripped apart the village of Claudy in County Derry; nine died in a customs office bombing in Newry. By now the death toll since the start of the Troubles three years previously had passed the 500 mark. Cardinal Cahal Daly would tell me later that he learned:

> ... *something of the power of evil to corrupt people, people who perhaps originally entered a paramilitary organisation with a certain idealism and a sense of a noble cause. They now find themselves accepting and doing things which they would never have thought possible. This is something quite frightening ...*
>
> ('My Education')

Inevitably the violence would spill across the border.

Friday, 17 May 1974. I finish work in Fallon's about 5.15 pm and walk up to my car, which is parked off Mountjoy Square. I drive down Parnell Street and cut across to Mary Street to collect my car-pool friend from Navan. We are just about to move off when there is a thunderous sound in the distance. We look back up Talbot Street to see a mushroom cloud of smoke and dust ascending. A bomb. Get out of the city fast. On the way home we hear that there are three bombs in Dublin, another in Monaghan.

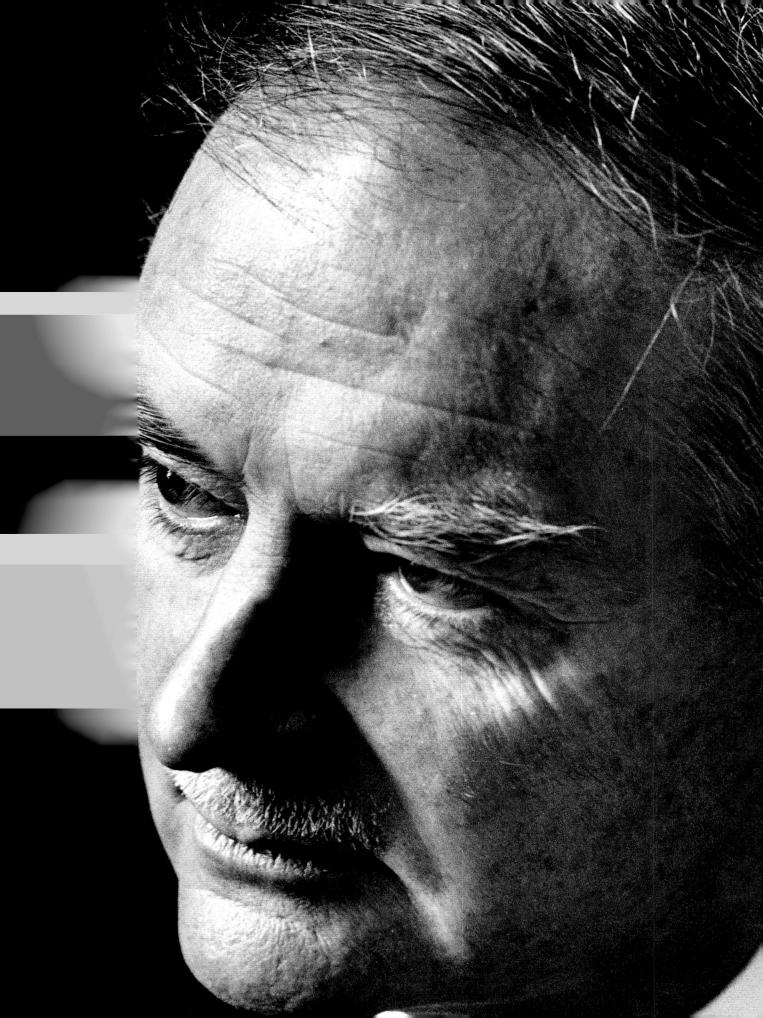

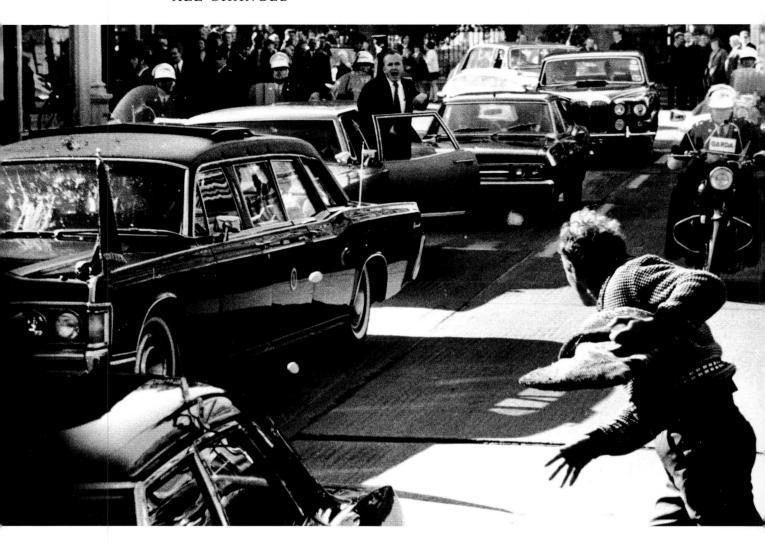

One of the Dublin bombs was in Parnell Street. I had driven past it a mere two or three minutes before it went off. If I had delayed in the office ... stopped to buy a paper ... Only when I reached the sanctuary of home did I begin shaking. The atmosphere in the city in the weeks following was unreal. A strange quietness. And yet our northern counterparts had had five years of this ...

Six months later, the violence hit England in a big way when two bombs in a Birmingham bar killed twenty-one people and injured hundreds. Olive Quinn was particularly upset. She had worked for Aer Lingus in Birmingham and had grown fond of the Birmingham people. We felt we had to do something beyond wringing our hands. With the help of a few friends we organised a peace march in Navan under the acronym SAVE — Stand Against Violence Everywhere. It was quite successful, even if it was only a 'thumb-in-the-dyke' effort. Naive even. But it proved that there were many others like us who wanted to shout, 'Enough! Not in our name.' Of course we subsequently had a visit from 'republican sympathisers', who told us they hoped we would be equally vocal against loyalist violence. The approaches of others were not so discreet. In a radio interview, Gerry Fitt recalled for me that the IRA had broken into his house in 1976 with one aim — to kill him.

I had a licensed weapon at the time and, had I not had that, they would have beaten the hell out of me with iron bars. I felt particularly incensed because I was a Catholic and these people were doing things allegedly in my name and in the name of Ireland. Whenever I appeared on television I would make my position clear — that I detested them and everything they stood for …

('My Education')

The old order was changing on many fronts. In February 1971, it was goodbye to shillings and pence — and half-crowns and florins too — and hello to decimal currency. As often happens with such change, many consumers felt that this was only a loosely disguised attempt to raise prices. 'Anyway,' said one dubious Kerryman, ''twill never catch on …' He was probably equally dubious two years later when Ireland joined the European Economic Community, but we were now part of a bigger entity that would

LEFT: A protestor hurls eggs at President Nixon's car, Dublin, 1970.
BELOW: Cearbhall Ó Dálaigh telephones a friend from his County Wicklow home on the night he sensationally resigned from the presidency, 22 October 1976.
Pages 90–91:
Gay Sheeran, Roscommon goalkeeper, fails to prevent an Armagh goal, All Ireland Semi-final, 1980.

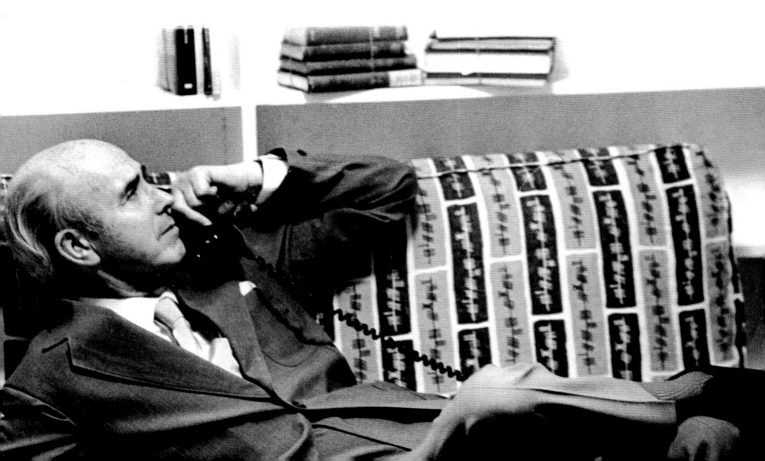

shape our economic destiny in a major way over the coming decades.

Another revolution would gain momentum in the 1970s, quietly but very determinedly and ultimately successfully. The first Women's Liberation group was formed in Dublin in 1971. As Jenny Beale points out in her book, *Women in Ireland*, they had a long road to travel:

> *Women in Ireland had fewer rights than in most European countries and many aspects of women's situation in the Republic compared unfavourably with that of their counterparts in Northern Ireland. Contraception was illegal, divorce was banned in the Constitution and abortion was a criminal act. Single mothers and separated women were ineligible for welfare payments and women were openly discriminated against in education, employment and the tax and welfare systems. A marriage bar was in operation in the Civil Service and other occupations, forcing women to give up their jobs on marriage. Women had few rights under family law and were in a highly vulnerable position if their marriages broke down. The illegitimacy law stigmatised children born out of wedlock — and their mothers with them …*

The marriage bar was abolished in 1973. There would be a celebrated 'contraceptive train' from Belfast importing those illegal objects. The sisters were on the march.

The Vietnam war ended in 1975, concluding fifteen years of pain and ultimate embarrassment for the USA. The media guru Marshall McLuhan observed that:

> *Television brought the brutality of war into the comfort of the living room. Vietnam was lost in the living rooms of America, not on the battlefields of Vietnam.*

There was plenty more brutality to be beamed into our living rooms. A bloodbath attended the birth of Bangladesh, the former East Pakistan. Civil war broke out in Angola and Lebanon. Pol Pot's Khmer Rouge wrought havoc in Cambodia and Idi Amin carried out a reign of terror in Uganda. Even the Olympic Games in Munich 1972 could not escape the slaughter. The brilliance of seven-times gold medallist Mark Spitz in the swimming pool and of the diminutive gymnast Olga Korbut were eventually clouded over by the invasion of the Israeli village by Arab guerrillas and the subsequent killing of both hostages and their captors.

But then we didn't have to import brutality into our living rooms from abroad. We had it here on our own doorstep. Sixteen people were killed by a bomb in the packed La Mon Hotel in Comber, County Down, in February 1978.

I make no apologies if this chapter reads like a litany of slaughter and shame, for

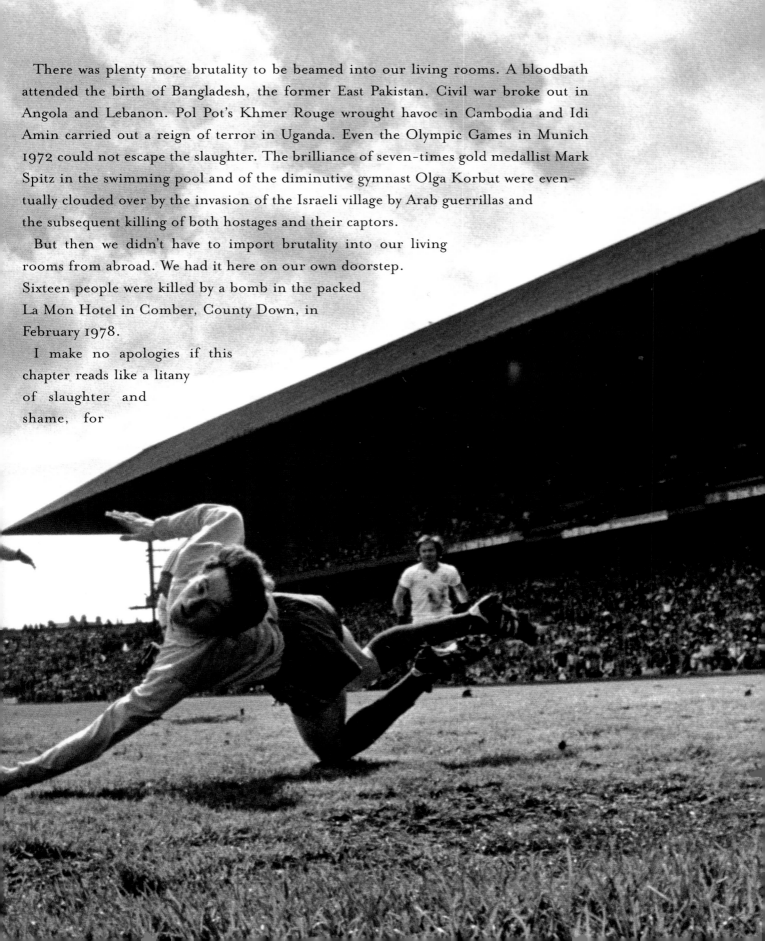

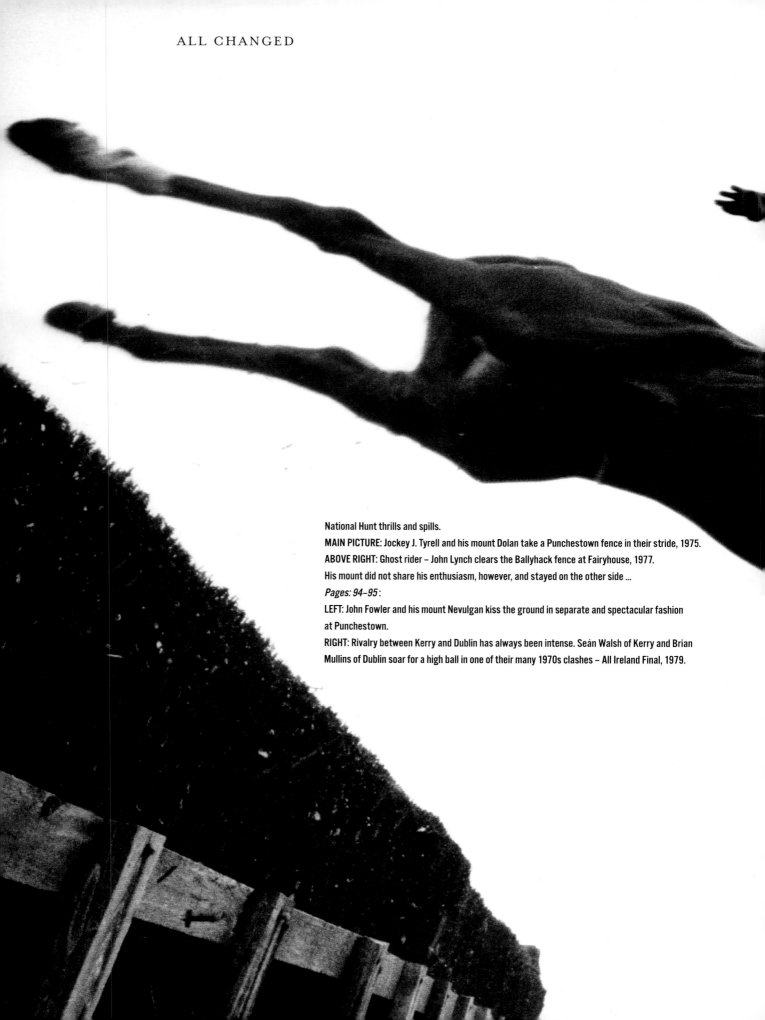

National Hunt thrills and spills.
MAIN PICTURE: Jockey J. Tyrell and his mount Dolan take a Punchestown fence in their stride, 1975.
ABOVE RIGHT: Ghost rider – John Lynch clears the Ballyhack fence at Fairyhouse, 1977.
His mount did not share his enthusiasm, however, and stayed on the other side ...
Pages: 94–95:
LEFT: John Fowler and his mount Nevulgan kiss the ground in separate and spectacular fashion
at Punchestown.
RIGHT: Rivalry between Kerry and Dublin has always been intense. Seán Walsh of Kerry and Brian
Mullins of Dublin soar for a high ball in one of their many 1970s clashes – All Ireland Final, 1979.

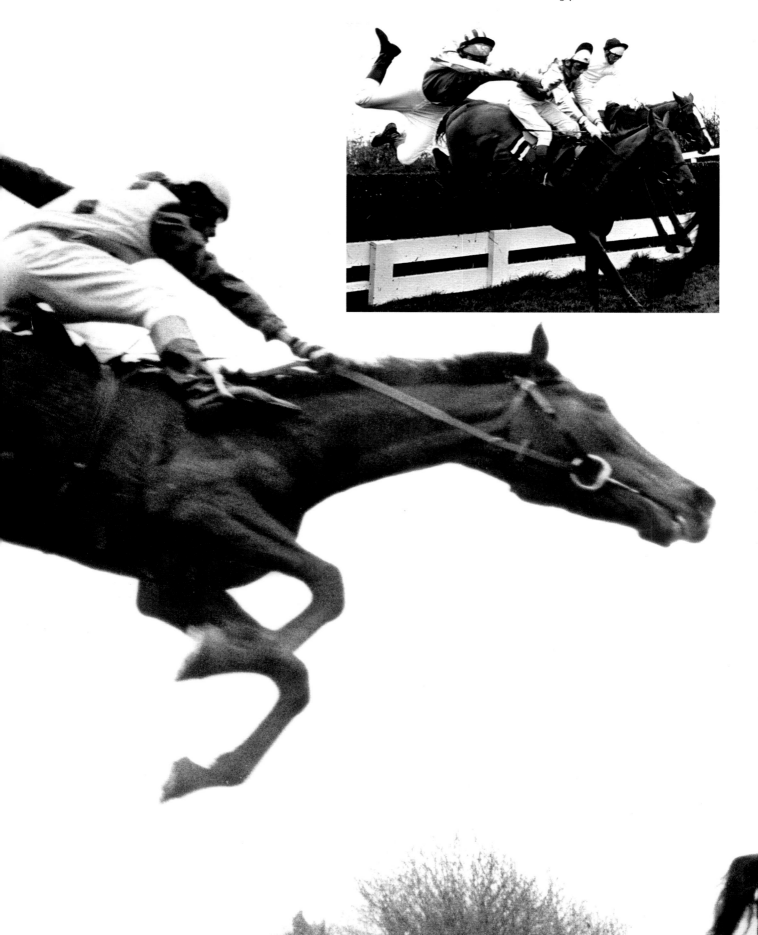

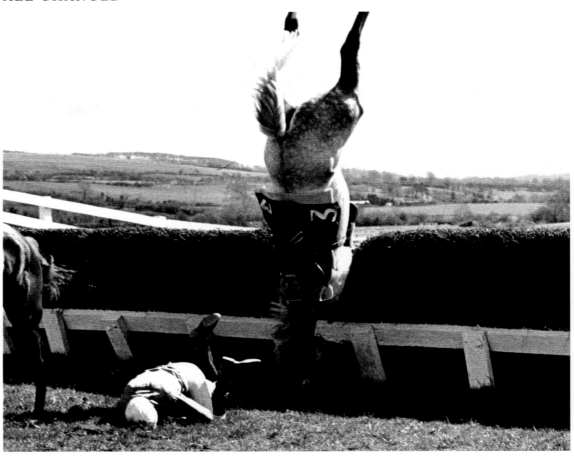

that is exactly what the decade became. Early in the decade the Government had invoked Section 31 of the Broadcasting Act to prevent RTÉ from reporting the activities of illegal organisations.

> *Of the 'wee six' I sing*
> *Where to be saved you only must save face*
> *And whatever you say, you say nothing ...'*

<div align="right">(Seamus Heaney)</div>

In November 1972, radio reporter Kevin O'Kelly found himself in breach of Section 31 and in jail for refusing to identify Seán Mac Stiofáin, Chief of Staff of the Provisional IRA, as his interviewee.

Broadcasting became my life when I joined RTÉ as an Education Officer for the pilot 'Radio Scoile' series in 1975. Two years later, I became a radio producer and thus began a love affair with the medium which would last a quarter of a century. In 1979, I did my first radio interview in a series on childhood, called 'I Remember, I Remember'. My guest was Nobel Peace Prize winner Seán McBride, who recalled for me the thrill of flying kites on a Normandy beach with WB Yeats and having 'ice-cream and lots of stories' in a Paris restaurant with the writer James Stephens. This was not work but simply privilege. There was a major expansion of the broadcasting service in the 1970s, with a

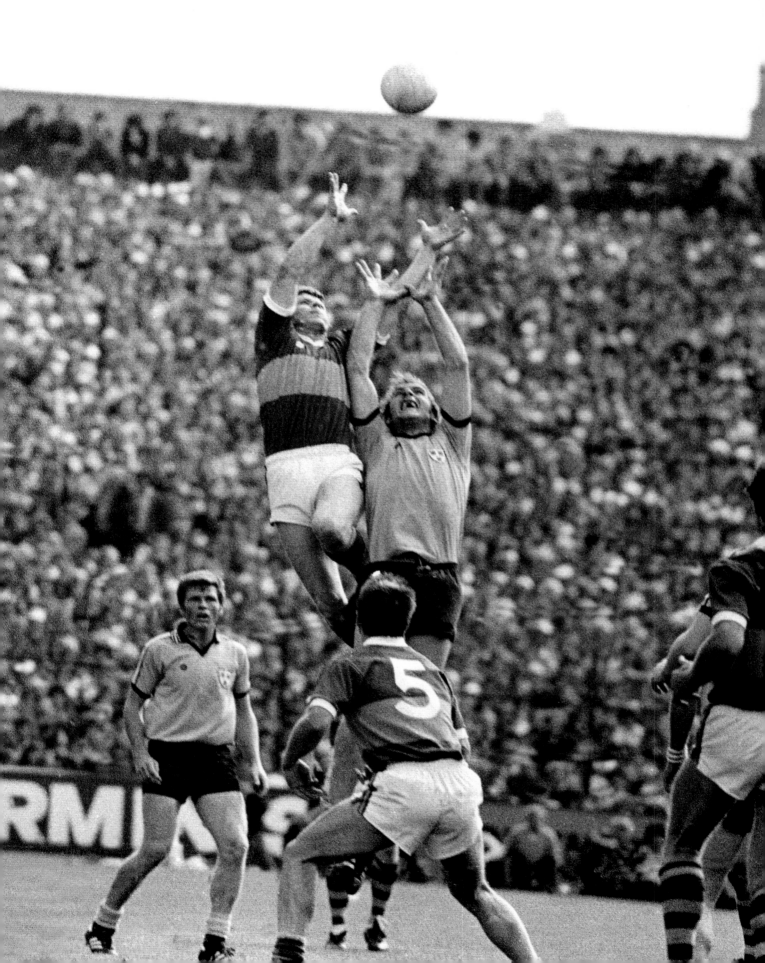

second television channel and two new radio services — Raidió na Gaeltachta and Radio 2 ('cominatcha in '79!') — and I was just glad to be a small part of public service broadcasting.

It entailed moving house again, from Navan to Greystones. This time the bungalow cost £22,000. My solicitor suggested I warn him in future if I were contemplating another house-move, because each time we bought a house it coincided with a serious bank strike! Six months in 1970, three months in 1976. It wasn't a great decade for industrial relations. There was a nine-week bus strike in 1974. Even Guinness's brewery went on strike, and I spent two weeks digging a garden when a strike closed down RTÉ in 1976. A four-month postal strike in 1979 helped to make that year the worst year for industrial disputes in the history of the state.

In just under seven decades the Republic of Ireland has had eight presidents, but amazingly, in the 1970s we had four of them. De Valera finally stood down after two terms of office. He was succeeded by Erskine Childers in 1973, who sadly died in office seventeen months later. His successor Cearbhall Ó Dálaigh lasted only two years, resigning in a sensational turn of events in 1976. He referred an Emergency Powers Bill to the Supreme Court and for doing this was publicly called 'a thundering disgrace' (or maybe worse!) by the Minister for Defence, Patrick Donegan. Ó Dálaigh resigned 'to protect the dignity of the office of president' and Patrick Hillery replaced him. Interesting times!

In August 1975, an era truly ended with the death at the age of ninety-two of 'The Long Fellow', Éamon de Valera. Love him or loathe him — and both camps had legions of followers — he had dominated Irish politics for sixty years. His dream of a quiet, pleasant, self-sufficient land had been shattered long before his death. The old order had very definitely changed. Paul Durcan's poem captures that fact in his own wry fashion:

LEFT: Silhouette in victory. Jack Lynch on the night of his biggest electoral victory, 16 June 1977. Fianna Fáil won eighty-four seats and had a majority of twenty in the Dáil.
OPPOSITE: Erskine Childers (left), fourth president of Ireland 1973–4, the only president to die in office, and Patrick Hillery (right), sixth president of Ireland 1976–90, twice unopposed.

When I was a boy, myself and my girl
Used bicycle up to the Phoenix Park;
Outside the gates we used lie in the grass
Making love outside Áras an Uachtaráin.
Often I wondered what de Valera would have thought
Inside in his ivory tower
If he knew that we were in his green, green grass
Making love outside Áras an Uachtaráin
I see him now in the heat-haze of the day
Blindly stalking us down;
And, levelling an ancient rifle, he says 'Stop
Making love outside Áras an Uachtaráin.'

LEFT: Charles J. Haughey, the most controversial politician of the last fifty years. Able and ambitious, he held ministerial posts in Justice, Agriculture and Finance in Fianna Fáil governments in the 1960s. Acquitted of charges of importing arms illegally in 1970, he spent five years in the political wilderness before returning as Minister for Health under Jack Lynch. He became leader of Fianna Fáil in 1979 and, during the following twelve years, was Taoiseach for four periods. He resigned following allegations of a telephone-bugging scandal in 1992.
BELOW: James McCann, retired Church of Ireland Archbishop of Armagh and Primate of All Ireland.

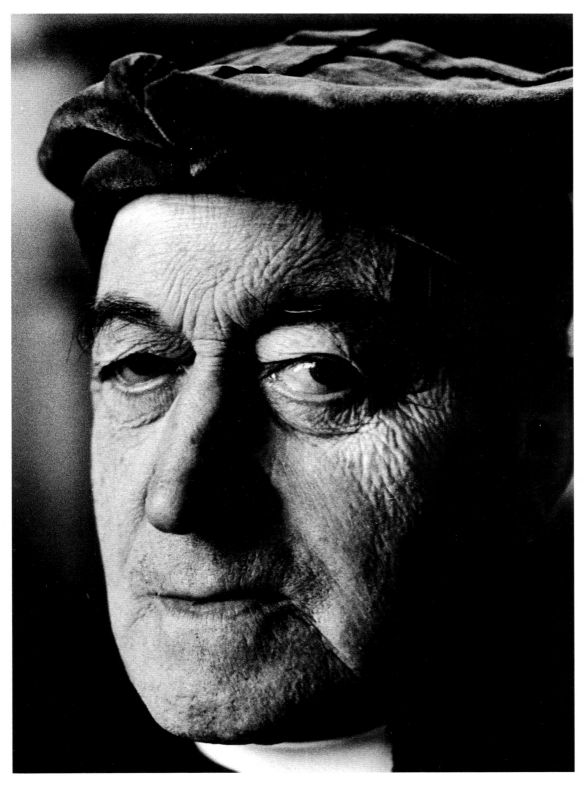

The final year of the decade did not bring many reasons to be cheerful. It began omi-
nously with the horrific Whiddy Island disaster when the oil-tanker *Betelgeuse* blew up,
killing over fifty people. It was a year of successive industrial disputes, as already men-
tioned. On 2 March, the darling of Cork hurling, Christy Ring, the scourge of
defences from Wexford to Galway, collapsed and died on a Cork street at the age of
fifty-eight. In August, the IRA struck another depraved blow for old Ireland when they
killed Lord Mountbatten, together with Lady Brabourne and two teenagers, by blowing
up his boat off Mullaghmore in County Sligo. On the same day, 27 August, the Provos
killed eighteen British soldiers with an explosion in Warrenpoint, County Down. And
on the political front, Margaret Thatcher became Prime Minister of the United
Kingdom and Charles J. Haughey emerged from the shadows of the Arms Crisis to
become leader of Fianna Fáil and Taoiseach. If only we knew then …

The one bright beacon of 1979 was the first-ever visit of a pope to Ireland. For three

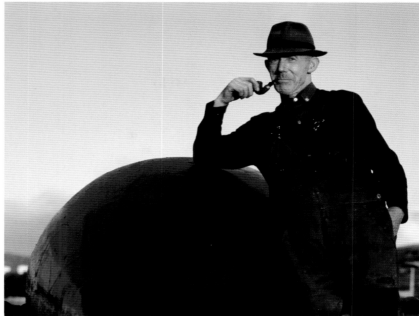

ABOVE: Sea-beast. A lone bullock at Bloody Foreland, County Donegal.
TOP RIGHT: *Oró, mo churraichín ó* ... a County Galway currach builder.
RIGHT: Snug lady. In Hannon's pub, James's Street, Dublin.

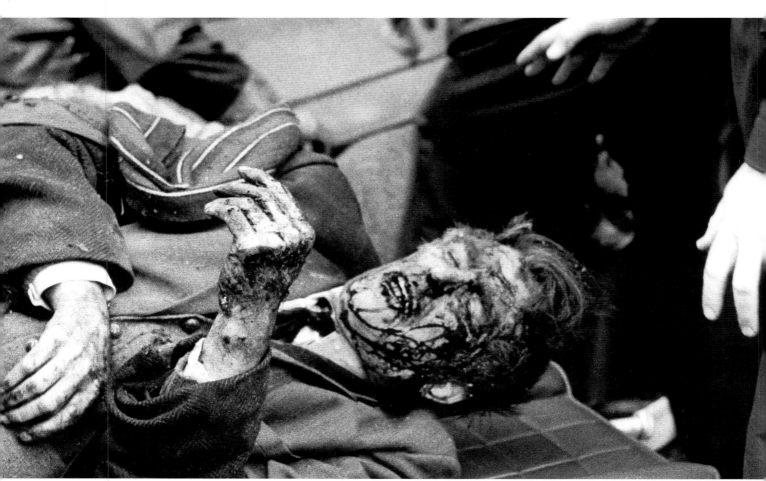

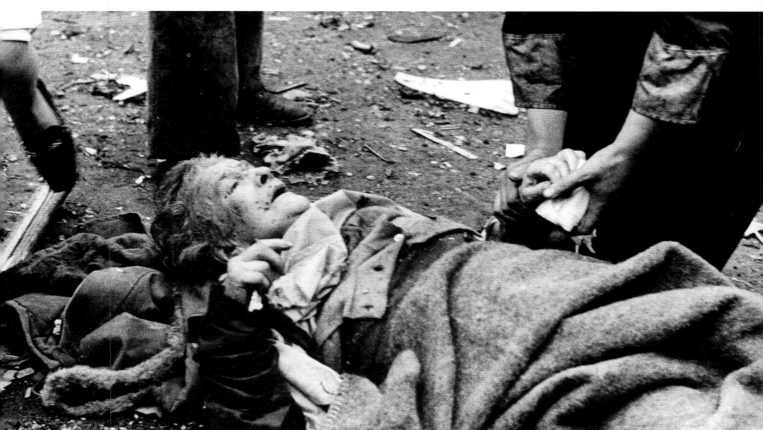

days in September/October, the energetic John Paul II drew massive crowds in Dublin, Limerick, Galway, Knock and Drogheda. Days of excitement and promise. I remember rousing my young daughters at 3.30 am to catch a special bus to the Phoenix Park to be part of that million-plus crowd. The excitement of his helicopter arrival was palpable and when he drove among the 'corrals' in his Popemobile, bronzed and dynamic in his white robes, it was just good to be there. On the final day of his visit, before a quarter of a million people gathered near Drogheda, he made an impassioned appeal:

> *On my knees I beg you to turn away from violence. Further violence will only drag down to ruin the land you claim to love and the values you claim to cherish ...*

He was in Boston twenty-four hours later when the Provos gave him his answer. NO. No pope on his knees would turn them away from 'the armed struggle'. Shortly afterwards, the death toll from ten years of violence in Northern Ireland reached 2,000, the equivalent of a decent-sized Irish town. The 1970s were just relentless violence. I remember engaging in verbal spats about this in the letters page of the *Irish Times* with a Provo sympathiser from Dundalk. For me the icon of the 1970s was a little boy of five

LEFT: Victims of the Dublin bombings, 17 May 1974.

BELOW: The dramatic rescue of the British submarine *Pisces* off the Head of Kinsale, 1973.

Page 104:
Pope John Paul II kisses Irish soil on disembarking from his plane, Dublin Airport, 29 September 1979.

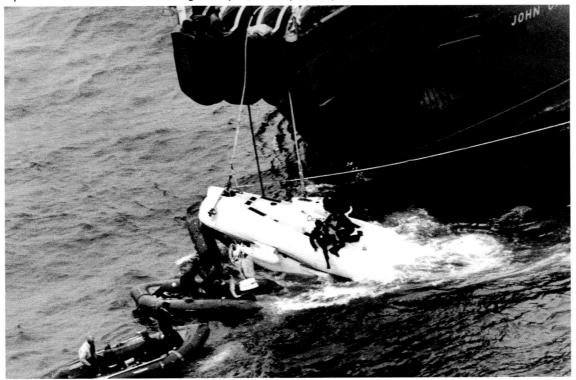

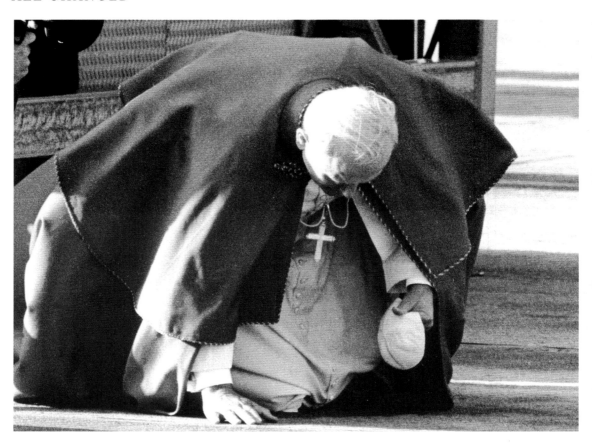

or six who was killed as he drove home his father's cows for milking. His greatest crime? To be driving home his father's cows. In the wrong place at ... No. Not true. He was in the right place. His own place. With his father's cows. Everything else was wrong. His name was Patrick Toner.

> *Two small girls*
> *Were playing tig near a car ...*
> *How many counties, would you say*
> *Are worth their scattered fingers?*
> (Desmond Egan)

George Otto Simms, the gentle and scholarly Church of Ireland Archbishop of Armagh, once told me in a radio interview:

> *My father was very gentle and a man of peace. He wanted to appreciate all that was Gaelic as well as all that was 'plantation' in our history. He left this lesson with me —* audi alteram partem, *hear the other side ...*
> ('My Education')

The problem in the 1970s was that nobody seemed to be listening. Nobody was hearing the other side. It was a bloody, bloody decade ...

1980's

John D. Sheridan died on I May 1980.

The name would have resonance only for an older generation. A former teacher and editor, 'John D' became popular in the 1950s for his humorous writings, in particular for his weekly column in the *Irish Independent* — a gently ironic look at the world about him. The subjects were mundane — onions, 'the right time', hot-water bottles — but his wry humour made the particular universal and made him a very popular writer at that time.

His passing represented the fading of an era of gentleness, of genteelism, almost. I mention it because I may have been indirectly responsible for it! John D Sheridan was found slumped over his typewriter in a Dublin nursing home. He had been typing a memoir in anticipation of a radio interview with me ... However, the memories were pleasant and humorous (I later had Gay Byrne, a lifelong fan of John D, record them) so I like to think his passing was a moment of delight rather than distress. And he kept his humour right to the end. On an earlier visit, I commented on the neat pile of spiritual books stacked on top of his locker. 'Oh, those,' he chuckled with a twinkle in his eye, 'I'm just cramming for my finals ...'

As for the 1980s, I associate the decade with a radio series I produced in 1985. That series was 'The Future of Work', an eight-part exploration of the nature of work and its possible evolution in the twenty-first century. It was based on the book of the same title, written by Charles Handy, a man who would subsequently become a regular radio contributor, a mentor and a friend. In his book, Handy argued that the world of full employment was no more and he posited challenging and positive ideas on the changing nature of work — how, where and why we will work in the future. The radio series opened with the following terse script:

> *We begin with a number — 239,867. It is not a telephone number. It is the number of people on the live register at this time. 239,867 people are deemed to be without a job. That represents roughly one person out of every five in the work place ...*

The lived-in face of actor Lee Marvin, taking a break from filming at Dunsany Castle, County Meath.

Unemployment and inflation were the twin scourges of the 1980s, just as violence had ravaged the 1970s. Not that violence had abated much either — in the first week of 1980 the Northern Ireland death toll had reached two thousand ...

In January 1980, I joined a huge throng of PAYE workers who marched through the streets of Dublin in protest at the crippling tax system. Nearly three-quarters of a million people demonstrated across the Republic but there was little hope of immediate relief. Inflation was running at over 18 per cent. Eighteen per cent! By the middle of the decade,

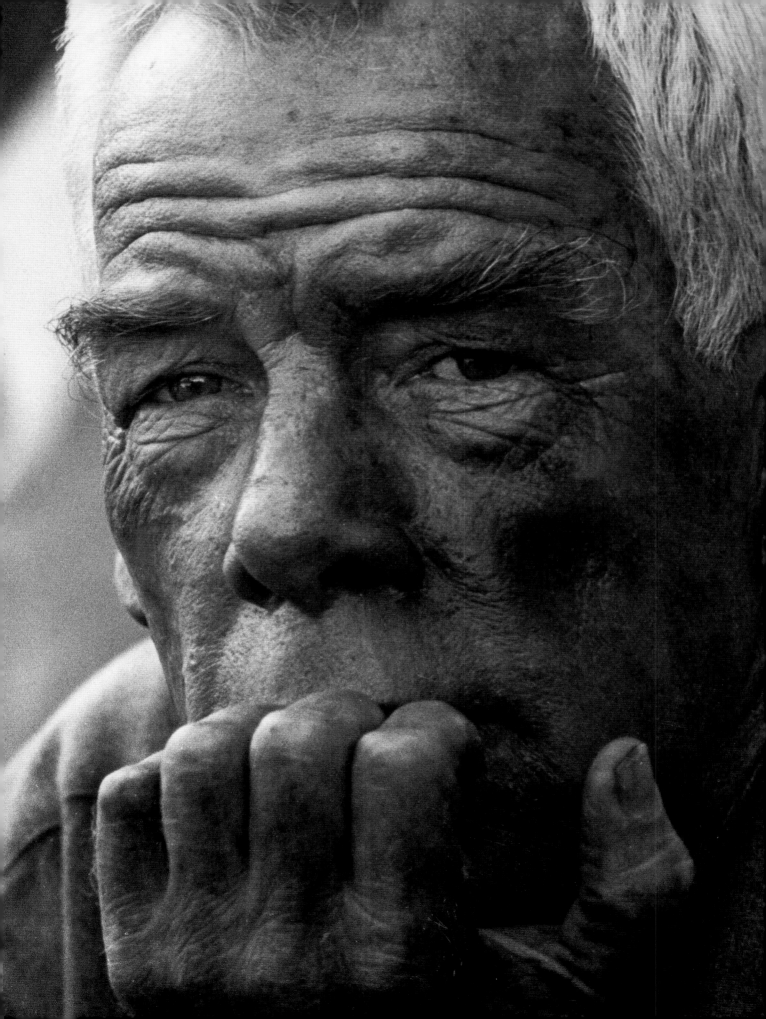

the National Debt had crept over £20,000 million. In 1982 alone, 700 businesses went to the wall. High numbers were the fashion of the decade. Later in the 1980s, phrases such as 'fiscal rectitude' were tossed at us and one Charles J. Haughey warned us that we would have to tighten our belts. CJH was the comeback kid of the 1980s. He emerged as taoiseach and leader of Fianna Fáil in 1979, having seen off the challenge of George Colley. Out of office in 1981, losing to a Fine Gael–Labour coalition. Back again a year later, despite a leadership challenge from Des O'Malley. Gone again nine months later but back again in 1987. Re-elected in 1989 after a protracted wooing of the newly formed Progressive Democrats. Five general elections in one decade (I seem to recall five ministers for education in 1982 alone!) — hardly the stuff of political stability.

Hardly surprising that in 1985 moving statues were reported in various locations! Hardly surprising to a buffeted electorate that in August 1986 the hurricane that devastated the countryside would be (aptly) named Charlie … I remember cowering in Bray railway station from the deluge, while down the road — or the river — a drenched Charlie Bird reported live on television, up to his waist in water from the overflowing Dargle river. At the same time he was fending off the jibes of the most unamused Bray citizens.

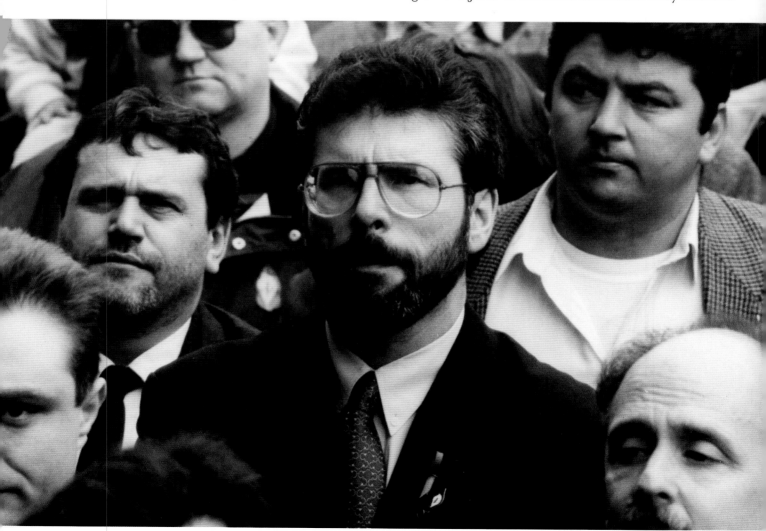

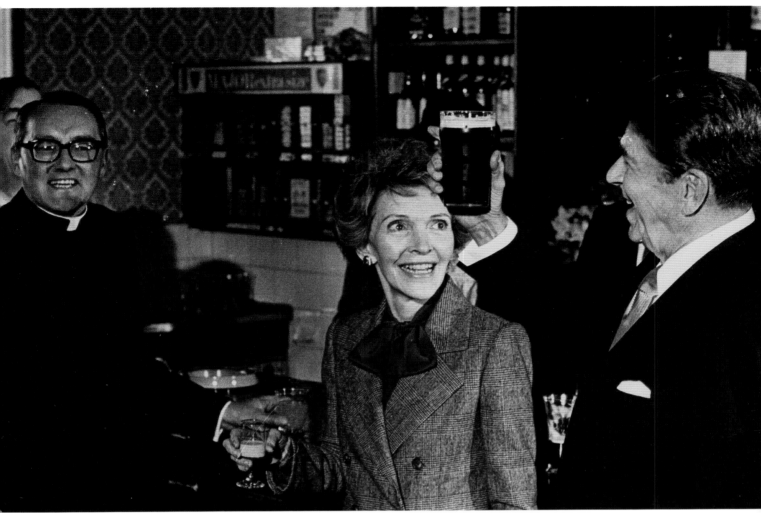

LEFT: A face in the crowd. Gerry Adams, who would later become leader of Sinn Féin and enter into dialogue with John Hume, culminating in the peace process.
ABOVE: A broth of a pint! President Ronald Reagan and his wife Nancy sample the local brew on their visit to his ancestral home in Ballyporeen, County Tipperary, June 1984.
Pages 110–111:
Casualties of the H-Block protest outside the British Embassy in Ballsbridge, Dublin.

The environment and how we were abusing it developed into a crucial issue in the 1980s. Our over-reliance on fossil fuels was producing a 'greenhouse effect' and causing a depletion in the ozone layer. Ultimately, we were told, this would cause a disruption in climate and severe changes in weather patterns. Ultimately. How far away was 'ultimately'? We were slow enough to change our lifestyles. Green politics emerged but remained largely at the margins. In 1982, an EEC survey declared Dublin to be the most polluted capital in the Community. In 1988 Dublin celebrated its millennium. One thousand years since the Vikings came a-calling. At this rate of pollution, would the capital last another thousand years? I recall doing an interview with the sculptor Oisín Kelly who, near the end of his life, said resignedly of his native city, 'Dublin today means nothing at all to me ...'

There was the occasional hopeful sign, however. In 1984, the DART (Dublin Area Rapid Transit) was eventually rolled out after years of waiting. A great boon — if you lived on the north–south coastal axis. For me, living in Greystones, County Wicklow, it was a welcome relief from travelling in packed diesel trains, often being 'accommodated' in a fume-filled guard's van.

Pollution of a far deadlier kind became a reality for the citizens of the Ukraine in April 1986 when reactor number four caught fire at the Chernobyl nuclear power station. The horrific effects of the fallout became all too apparent in the following years, particularly when campaigners such as Adi Roche forcibly brought to our attention the plight of the children of Chernobyl.

The shadow of death hung over our land also. The violence of the Northern Ireland 'Troubles' continued unabated. Seventeen people were killed by a bomb at the Dropping Well public house in Ballykelly, County Derry, in December 1982. A year later, the New Ireland Forum (recently established to promote dialogue but boycotted by the Unionists) was told that the cost of violence in Northern Ireland since 1970 approximated to £11,900 million.

The year 1980 had brought another dark dimension to the Northern Ireland 'problem'. Republicans in the H-Block prisons, claiming political status, demanded the right to wear their own clothes, were refused and went on hunger strike. That hunger strike ended in December 1980 on the intervention of Cardinal Ó Fiaich but a second one followed three months later, initiated by Bobby Sands. Sands was entered as

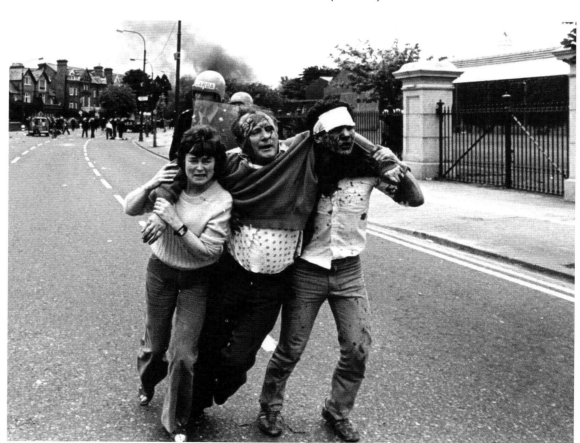

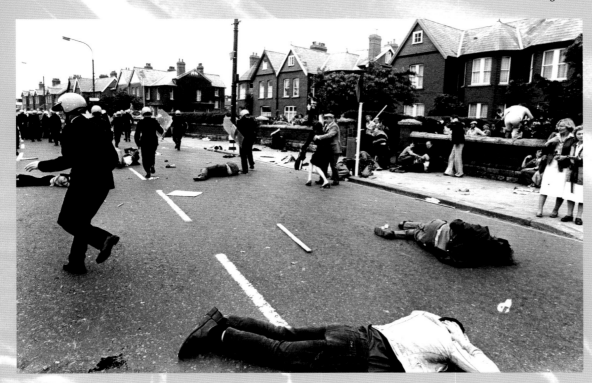

a candidate in the Fermanagh-South Tyrone by-election and duly defeated Harry West, the Unionist candidate.

Sands was an MP for less than a month. He died after sixty-six days on hunger strike. Over 50,000 people attended his funeral. Nine other hunger strikers died in the following six months. It was a dark and depressing time. Images of gaunt, bearded, blanketed figures who persisted in the 'dirty protest' (smearing their excrement on cell walls). Black flags. Violent protests — as depicted in Colman Doyle's graphic photographs. Highly emotive funerals. The election strategy spread to the Republic, when two strikers were elected to Dáil Éireann. Margaret Thatcher was not for turning. All futility and waste until the families of some strikers could take no more and sought medical intervention on their behalf. In October 1981, the Provisional IRA called off the hunger strikes and ultimately all prisoners were allowed to wear their own clothing at all times. The closing of one of the grimmest chapters of the 'Troubles', but sadly, only a chapter.

The men of violence turned to a new source of 'fundraising' — kidnapping. Businessman Don Tidey (1983), Jennifer Guinness (1986) and dentist John O'Grady (1987) were abducted and eventually freed, not without cost. A garda and a soldier died in the rescue of Don Tidey in a Leitrim wood. Another kidnapping went totally wrong. Shergar, the most outstanding Derby winner for decades, was abducted from his stud in County Kildare and never found, despite extensive searches. One wag (there's always a wag) insisted that Shergar had to be still in Kildare: 'Sure he never got further than a mile and a half ...'

There was a spark of hope in 1985 when Garret FitzGerald and Margaret Thatcher signed the Anglo-Irish Agreement, giving the Republic a consultative role in the

The religious life in Ireland ...

BELOW: The ebullient Monsignor James Horan on the realisation of his dream, the opening of Knock Airport in County Mayo (behind him another Mayoman, Charles J. Haughey).

TOP RIGHT: Try it on for size yourself! Archbishop Tomás Ó Fiaich returns from Rome with his cardinal's biretta, June 1979.

BOTTOM RIGHT: The hermit's life. Sister Irene Gibson, a Benedictine nun from Dublin, who became a self-professed hermit, living in a barren landscape in County Mayo.

Pages 114-115:

TOP LEFT: Coalition partners, Tánaiste Dick Spring, leader of the Labour Party, and Taoiseach Garret FitzGerald, leader of Fine Gael.

BOTTOM LEFT: Eamonn Casey is consecrated Bishop of Kerry, Killarney, 1969.

RIGHT: Sinéad O'Connor performs at the Free Mandela concert, Dublin, 1988.

running of Northern Ireland for the first time. The Unionists were not amused and protested violently in Belfast, burning a Thatcher effigy when the Anglo-Irish Conference met for the first time. Maggie was under fire from all sides. A year earlier, she had been lucky to escape with her life when an IRA bomb devastated the Grand Hotel, Brighton, during the Tory Party Conference. It was an audacious attempt by the IRA who subsequently bragged, 'Today we were unlucky, but remember we have only to be lucky once....'

Their carnage continued. On Remembrance Day, 8 November 1987, as people assembled for the commemorative parade in Enniskillen, County Fermanagh, the IRA detonated a bomb in a disused school. A 'soft target', as the analysts would say. Eleven people died, including three married couples. Scores were injured. One of the fatalities was a young nurse, Marie Wilson, whose life ebbed away as she held her father's hand. Gordon Wilson, a self-proclaimed 'ordinary wee draper from Enniskillen', found himself catapulted into world prominence when, in an extraordinary interview on BBC Radio hours after his daughter died, he forgave those who had killed her. In the midst of all the hatred and slaughter, he became an icon of love and forgiveness. He had a simple one-line philosophy: 'The bottom line is love.' Some years later, I was privileged to interview him for a radio series, and he amplified that philosophy:

I believe there is a God and that God loves me. I accept His word when He taught us the Lord's prayer with the words 'forgive us our trespasses as we forgive those who trespass against us'. You either believe that or you don't. I do ... So I ask myself the question 'Who is my neighbour?' And the answer I get is that my

neighbour is not just my Protestant neighbour and not just my Catholic neighbour. It must include my terrorist neighbour because Christ died for them too …

('My Education')

There was nothing at all 'ordinary' about Gordon Wilson. His extraordinary charisma touched all those who were lucky enough to meet him. He was surely a man chosen for his time.

And of course the 1980s were not all horror and hairshirts. There were delights all around. I recall bringing our children to see *ET* in the Adelphi cinema in Dublin and having the unique experience of standing with the audience in spontaneous applause and not a few tears as ET returned home. I have never experienced such a tribute before or since in the cinema — and it was a richly deserved tribute. We feasted on the sumptuous *Brideshead Revisited* on television. And for those who wanted to feast on lavish reality on television, there were two royal weddings: Charles and Diana in 1981 and Andrew and Fergie in 1986 — both fairytale occasions but, sadly, both with anything but fairytale endings. My abiding memory of the latter wedding is watching it on television in a Wexford hotel (where we were on holiday). 'Isn't Andrew a fine cut of a fellow?' drooled one of the women in our company. 'Hmph! fine cut indeed!' came the grudging reply from one of the totally uninterested males. 'I'd love to see him under a dropping ball in the Crossabeg square with two minutes to go in the junior football final …'

LEFT: Two Kerry 'greats' on a wild Kerry beach. Páidí Ó Sé and Paddy Bawn Brosnan on Dunquin beach, 1985.

RIGHT: So what? Irish rugby player Jim McCoy is unfazed by the 'Haka' performed by the All-Blacks at Lansdowne Road, Dublin, 1989.

BELOW: 'Sam' comes home. Páidí Ó Sé, captain of the Kerry All Ireland winning team in 1985, holds the Sam Maguire Cup aloft in what Kerrymen consider Sam's natural home – the Kingdom.

Advances in technology brought other delights. The digital revolution was upon us. Watches, calculators, videos, hi-fis, word processors transformed our lives. The age of the scratchy old vinyl was giving way to the era of the compact disc. And what musical delights emanated from these CDs! The 'thrilling' Michael Jackson, the 'Karma Chameleon' of Boy George … You could 'Relax' with Frankie Goes to Hollywood or be 'Like a Virgin' with Madonna … As if.

And at last, in September 1981, we got our very own National Concert Hall. Watching the opening night on television, I, like thousands of others, was transported back through the years to a time when, in that same hall — then the Aula Maxima of University College Dublin — I had registered as a BA student or sweated through final exams … But at last we had our concert hall and years of delights lay ahead.

On the stage, the Field Day Company treated us to *Translations*, Brian Friel's marvellous exploration of language, history and identity. I sat riveted in the Gate Theatre watching a young Liam Neeson play Doalty Dan Doalty, of whom Hugh, the hedge schoolmaster, says:

> *Sophocles from Colonus would agree with Doalty*
> *Dan Doalty from Tulach Álainn — 'To know nothing*
> *is the sweetest life …'*

BELOW: Last of a breed. Coalminers from the now defunct Arigna mine in County Leitrim.
RIGHT: Master of the turf. The veteran English jockey Lester Pigott, whose career spanned five decades during which he rode over 5,000 winners, including nine Derby victories.
Pages 120–121:
LEFT: One man and his dog. Joe McHugh of Liscannor in County Clare with one of his champion coursing greyhounds.
RIGHT: Burren beauty. Nessa Linnane admires the flowers of the Burren, County Clare.

Frank McGuinness very keenly observed the *Sons of Ulster Marching Towards the Somme*, and Tom Murphy's *Bailegangáire* was tailor-made for Siobhán MacKenna, who sadly would depart the world stage in 1986.

Every decade brings its tragedies and the 1980s were no exception. Valentine's Night in 1981 became a night of horror for the young people who attended the Stardust Disco in Dublin. The building was consumed in an inferno which took the lives of forty-four people and injured hundreds of others. A subsequent tribunal established that the fire had probably been started deliberately, and castigated the owners and Dublin Corporation over the absence of safety precautions.

Public safety became a major issue internationally following the disastrous loss of life at Bradford City football ground – through a fire in one of the stands – and the Heysal Stadium in Brussels, when Liverpool supporters went on a rampage during the European Cup final. In 1980, an horrific rail crash in Buttevant, County Cork, killed seventeen people. Five years later, on an even more horrendous scale, an Air India Boeing 747 crashed off the south coast killing all 329 on board. I felt a personal loss in September 1982 when Princess Grace of Monaco died. The goddess of the silver screen, my teenage infatuation, gone in such cruel fashion. Her car spun off the corkscrew road

in Monte Carlo, an eerie replay of a scene from *To Catch a Thief* when she and Cary Grant sped down that same road. Earlier in the decade, the music died when an assassin shot John Lennon outside his New York apartment.

We had been alarmed by assassinations in the 1960s. Twenty years later, we had almost become inured to such events following a spate of assassination attempts: on President Reagan of the USA, on Pope John Paul II, on President Sadat of Egypt, on Prime Minister Palme of Sweden and on Prime Minister Indira Gandhi of India – the latter three proving fatal. The world was becoming an increasingly violent place, senselessly violent. A gunman walks into a McDonald's restaurant in California and slaughters twenty people. Why? 'I don't like Mondays,' he told police before killing himself. Another gunman leaves a trail of carnage, killing fifteen people in the English town of Hungerford. Why? He never said.

In the 1980s, we learned of two disasters which would ultimately impact on a global scale. As early as 1980, there came warnings of an impending famine in East Africa, the culmination of years of drought and local wars, but nothing could prepare us for Michael Buerk's graphic television reports from Ethiopia in 1984. I watched while on holiday with our family in Rosslare. Here we were enjoying life in comfort and plenty. There they were gaunt, emaciated, clinging to life. In their thousands, millions maybe. It wasn't right. How could we sit back and watch? I came back to work and wrote a letter to RTÉ's in-house magazine appealing for help to set up a Third World fund which would help stem the famine tide by supporting long-term development projects. The call was answered and the fund got underway through staff payroll deductions. Many other organisations were setting up similar funds. Ours was but a small effort, but at

least an effort. Sadly, twenty years later, the fund still exists because the need still exists, probably even more so.

Other people answered the call on a far greater scale. Bob Geldof set up Band Aid and eventually organised the massive 1985 Live Aid concert – 'rocking the world for the hungry'. Band Aid was a two-edged title. The rock bands came together to provide aid but in reality that was what it was – a 'band-aid' on a festering sore that the developed world is still trying – and often failing – to heal.

In April 1984, the United States Secretary for Health, Margaret Heckler, announced the discovery of a virus that would wreak havoc across the globe for the next twenty years and is today a bigger threat than ever – HIV/AIDS. Twenty years on, its prevalence is even greater than had been anticipated. Twenty-five million people dead. Fourteen million children orphaned. Our consciousness was raised only slowly, initially by the death of Rock Hudson in 1985. Rock Hudson? The seriously 'heterosexual' star of all those romantic comedies with Doris Day? HIV/AIDS would spread inexorably across the globe, no respecter of boundaries and ultimately becoming the great humanitarian problem of the twenty-first century.

Enough darkness. Let the light in. Sport. Lots of stories to delight, divert, inspire. The cycling exploits of Stephen Roche and Sean Kelly thrilled the nation. Kelly owned the Paris-Nice race, winning it seven times, but Roche crowned everything in 1987, winning the amazing treble of the Giro d'Italia, the Tour de France and the World Professional title. An Irishman winning the Tour de France? Unthinkable! But it's

true — there he is beaming on the winner's podium in Paris. No, not CJH, you fool — the cherub-faced athlete standing in his shadow. Eamonn Coughlan, world champion at 5,000 metres in 1983, John Treacy, silver-medallist in the marathon at the 1984 Olympic Games in Los Angeles and 'wee' Barry McGuigan, world featherweight boxing champion in 1985 — a notable trio of achievements on the world sporting stage.

Rugby 'triple crowns' for Ireland in 1982 and 1985 (who can forget lip-reading captain Ciaran Fitzgerald's rallying call to his troops: 'Where's your f****** pride?') and the great little mare Dawn Run completing the Gold Cup Champion Hurdle double at Cheltenham. Weren't we on top of the world — almost? Indications of greater days ahead on the soccer pitch came in Stuttgart in the European Championships of 1988

LEFT: Swing your garda partner! Gardaí do their bit for community relations at a children's Christmas party in Dublin.
BELOW: The long journey home. An Atlantic salmon leaps the falls on a County Leitrim river.
Page 125:
An t-oileánach. A fine study of a man from Clare Island.

when Ray Houghton put the ball in the England net to claim a memorable victory over the 'auld enemy'.

Five in a row. Unimaginable! Five All Ireland football titles in a row! This fantastic achievement was within the grasp of the mighty men from Kerry, until Seamus Darby from Offaly sort of 'nudged' his way into history with a last-minute winning goal – thus consigning to the Kingdom dustbins the five-in-a-row T-shirts, records, scarves, cigarette-lighters … It was and will forever remain a beautiful dream.

The Gaelic Athletic Association celebrated its centenary in 1984. I remember this because my native Meath won the Centenary Cup that year. A portent of things to come? Yes – successive All Irelands in 1987 and 1988 under the maestro manager Sean Boylan. We were all set for five in a row until those Cork fellows spoiled the party for the next two years … Going to the All Ireland Final in 1987 reminded me what a wonderful, special day 'Final Day' is in Irish life. (I needed reminding because Meath had not won a final for twenty years!) I resolved to make a radio documentary which would try to capture the unique atmosphere of 'Final Day' – a sound-picture embracing all the passion, tension, elation and dejection of the day as captured in the reaction of the fans, the reflections of players and managers, Micheál Ó Muircheartaigh's highly charged commentary, the touts, the hawkers, the pub atmosphere. Nineteen hours of tape were eventually compressed into forty-five memorable minutes of programme with the help of a wonderful sound engineer, Mick Bourke. The programme won major awards in Dublin and New York but the real satisfaction was in realising the dream of capturing the spirit of that unique day. It was summed up in the closing words when a Meath fan says to his friend, 'Sure we're only out for the day. This time next year we could be going down the road with a few flowers over us …'

There was All Ireland hurling success for Offaly and Galway – a major breakthrough for both counties. Galway's success in 1980 was made even more memorable by captain Joe Connolly's wonderful victory speech in Irish (an aspect of Final Day which is normally a source of cringeful embarrassment) and Joe McDonagh's spirited rendering of 'The West's Awake'. Only out for the day. Indeed, but what a day!

In 1984, an American president visited Ireland for the third time, but the novelty was wearing off. Somehow the appeal of a former Hollywood actor acknowledging his roots by drinking a pint of Guinness in the Ronald Reagan lounge in Ballyporeen, County Tipperary, was less than magnetic. A lot of people were unhappy with his support for the Contra rebels in Nicaragua and the sale of weapons to Iran, but Reagan romped to a second term as president later in 1984, proclaiming to us all, 'You ain't seen nothin' yet.' And he did face up to the Communist threat. Throughout his second term, the Cold War went into meltdown, culminating in the extraordinary domino collapse of Communism across eastern Europe as the decade ended.

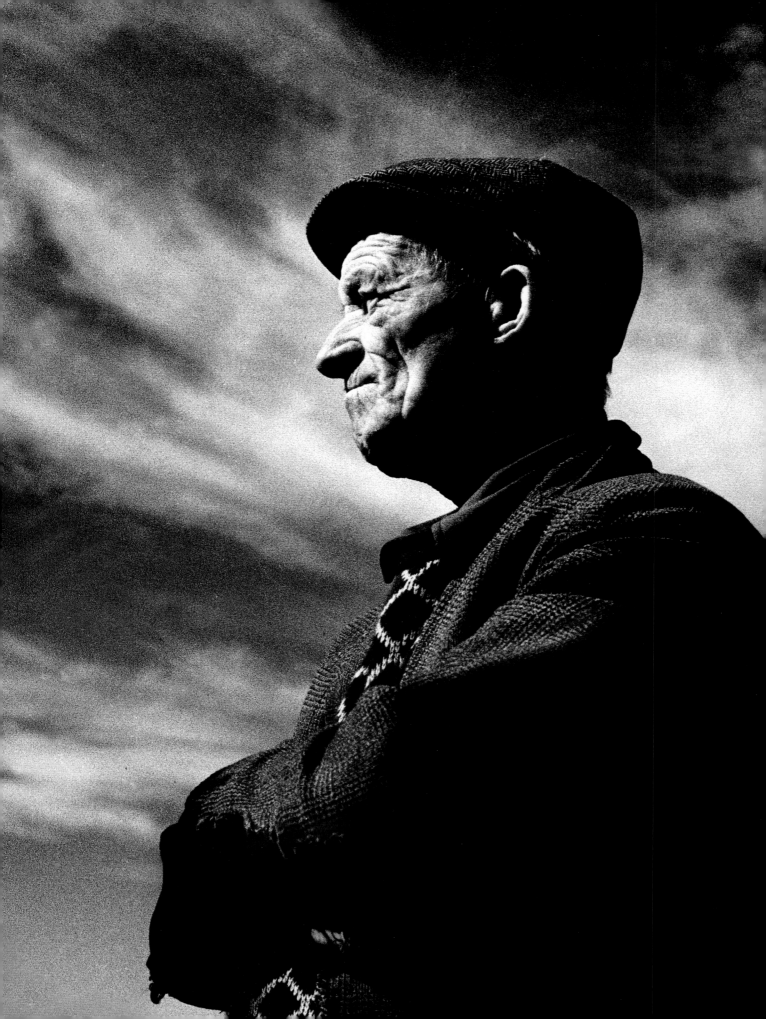

We watched, almost in disbelief, as history unfolded live on our television screens — the dismantling of the Berlin Wall; the Christmas Day execution of the hated Romanian despots, the Ceaucescus; the emergence of a charismatic new leader of the Soviet Union — Mikhail Gorbachev, who added a new word to our political lexicon: *perestroika*, the reconstruction of the political and economic systems of the soon-to-crumble Union. Gorbachev, who visited Ireland in 1989, was a breath of fresh air from beyond the Iron Curtain. Reagan loved to tell of his conversation with Gorbachev. When boasting of American democracy, he said, 'In America, people can stand outside the White House and shout "Ronald Reagan is a bum!"' Gorbachev is said to have replied, 'Is the same in Russia. Anyone can stand outside the Kremlin and shout "Ronald Reagan is a bum!"'

The *perestroika* days were far removed from the days that were recalled for me in a 1992 radio documentary by Olimpia, a teacher from Romania, who grew up under the Ceaucescu regime:

> *It was fear, just fear. You were nothing. You had nothing … Overnight a military man and his family just moved into our house. My mother became a slave to them. I was terrified by his black boots which he left outside his door every night. I tried to touch them but I couldn't … Fear. Fear of the black boot …*
>
> ('Olimpia')

If Ronald Reagan dominated American politics through the 1980s, Margaret Thatcher ruled Britain as the Iron Lady right through the decade, winning three successive elections. A war in the Falklands, a face-down of striking miners, intransigence on the Northern Ireland problem — the lady was definitely not for turning. Another new word had entered the political lexicon — Thatcherism — with all its echoes of individualism and privatisation. 'Thatcher's Children' represented a new breed — yuppies (young, upwardly-mobile persons) for whom compassion was out and consumption was very definitely in. Work hard, play hard — and spend, spend, spend!

And what of the children of the Republic? Well, there were more of them for a start. The 1986 Census showed a 5 per cent increase in population over the 1979 figure. There were also more of them unemployed, as mentioned earlier. And those who were working were shouldering more and more debt (by 1987, one-third of all tax revenue went to servicing the National Debt of over £26,000 million) and experiencing more and more cutbacks in expenditure in the name of 'fiscal rectitude'. In terms of government we couldn't quite make up our minds. The 1980s were a see-saw decade

LEFT: The man who would dance for Ireland! Charles J. Haughey dances a hornpipe on the foredeck of the yacht *Taurima*, on his way to his own island of Inishvickillaun.

Page 128:

Island wedding. Mary Gavin sails from her island home in Clew Bay, County Mayo, with her three bridesmaids and her father on her way to marry Séamus Hughes in 1983.

politically — Charlie stepped out and Garret stepped in. Charlie stepped in again and Garret stepped out — and in again, until at the close of the decade Charlie stepped in one more time, this time with the help of the newly formed Progressive Democrats under Dessie O'Malley. We had three referenda — saying yes to the Single European Act but no to divorce and abortion.

There were signs of hope amid the gloom and uncertainty. John Hume had an initial meeting with Gerry Adams. A parish priest with a mischievous glint in his eye confounded everyone by getting an airport 'on a bog at the top of a mountain in the middle of nowhere' up and running. The second miracle of Knock! We opened our first toll-bridge and our first motorway, by-passing the town of Naas in County Kildare. Corporal punishment was banned in schools. I shudder to think of my days as a young teacher when I would go into Hely's Educational Supplies in Dame Street, Dublin, for a gross of copies, a box of chalk and a couple of canes ... educational supplies, indeed.

It was hoped that the 1990s would bring a rising tide to a new Ireland. So it seemed to An Taoiseach, Charles J. Haughey, in 1987 when he opened the International Financial Services Centre in Dublin's dockland. This would be 'the golden city — the new Bloomusalem in the Nova Hibernia of the future ...' In the words of another Dubliner: 'darlin' words, Charlie, darlin' words ...'

1990s

We begin with a journey. A long walk to freedom was finally realised in February 1990 when Nelson Mandela was released from Robben Island prison after twenty-seven years in captivity. It was equally the beginning of another journey — to peace, justice and reconciliation in his beloved South Africa. It was a time of hope. Here in Ireland, the fragile seeds of hope were being nurtured also. In 1994, the Provisional IRA declared a ceasefire. In the words of Seamus Heaney, it was 'a space where hope can grow'.

A reason to be cheerful, but other reasons had appeared before 1994. Italia '90 for one. We might have scraped into qualification for the World Cup finals, but once the caravan set out for Italia '90, floating on a thousand mortgages, the party was about to begin. A pattern unfolded. Streets deserted as we gathered around television sets in home, pub or place of work. Then euphoria. Street parties. Mardi Gras time. The nation held its collective breath as Packie Bonner saved the crucial penalty against Romania, and then exploded into celebration as Dave O'Leary scored. We had qualified for the World Cup quarter finals for the first time. We were going to Rome, no more the gallant losers. Manager Jack Charlton's main worry was that he was running out of underpants, as he had not expected to be away from home for so long! And mortgages had to be renegotiated. What matter if a swarthy little Italian called Toto Schillachi ended our dream by slipping one past Packie? The carnival was over, but what a carnival (and we would have our revenge on the Italians four years later in the USA)! A summer to remember.

On a personal level, it was a summer to remember too. For part of Italia '90 the Quinn family was on holiday in Spiddal, County Galway. The visit seemed to kindle a longing in Olive to return to her country roots. An affinity for the Galway landscape and its people prompted the dream. Could we not live here, permanently? It seemed like a crazy dream. My workplace was, after all, 150 miles away, but I too was swept along by that dream and, a year later, we moved home to Killeenaran in South Galway. A brave decision in many respects. A pioneering move (Wagons West!) for its time. A move that was not without sacrifice and occasional pain but one that ultimately brought a lot of contentment, particularly for Olive.

The presidential election of 1990 was a watershed in Irish political life. Heretofore the presidency had been seen as a sinecure for retired male politicians. Mary Robinson's entry into the race in 1990 would end all that. Despite (or maybe with the help of) Padraig Flynn's ill-chosen words on national radio in an attempt to undermine her candidacy, the lawyer and senator from Ballina became our first woman president. In a moving and poetic inaugural speech, she invited people to 'come dance with me in Ireland'. She made a particular

John Bruton TD, twice Minister for Finance; his 1982 Budget caused the defeat of the government in a Dáil vote. Leader of Fine Gael 1990–2001 and Taoiseach of a coalition government 1994–97. EU Ambassador to the US in Washington.
Page 132:
Light at the end of the tunnel. Seamus Mallon and John Hume of the SDLP take a break from the talks that led to the historic Good Friday Agreement in 1998.

130

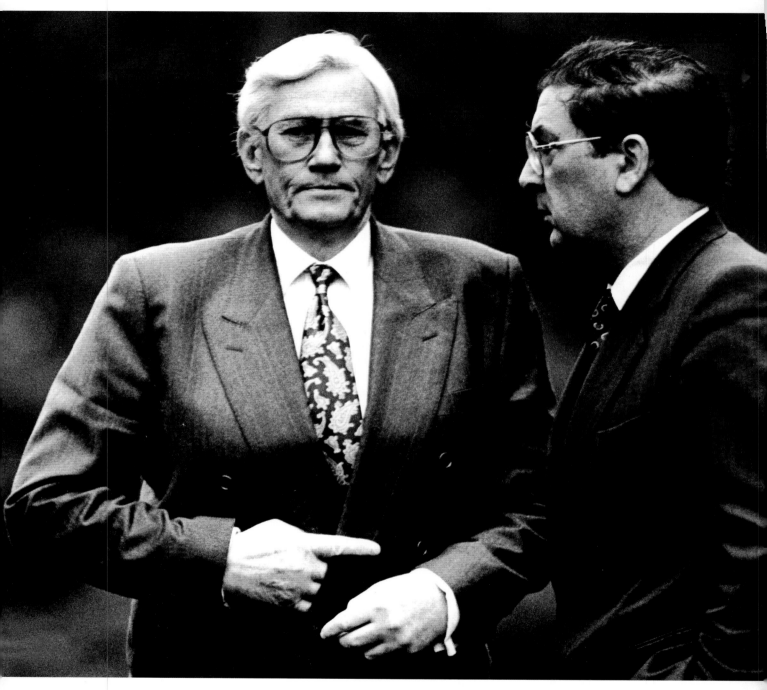

issue of the Irish diaspora, for whom she would keep a candle permanently lit in Áras an Uachtaráin. It was, to quote from Máire Bradshaw's poem, 'high time for all the Marys' — an open, outgoing presidency that would in time be built upon and extended with warmth and grace by her successor, Mary McAleese.

This is the Ireland we need. An open society where the individual still counts, where ideas can grow from the bottom and are not always imposed from the top, where there is less prejudice among the different sections of our society.

The words are those of Hilda Tweedy, a lifelong campaigner on women's issues. She was speaking as a contributor to *The Tinakilly Senate*, a radio series I produced in 1993. A simple idea. Convene a 'senate' of wise men and women in a restful location (Tinakilly House, County Wicklow) to debate on the theme 'Renewing the Spirit of Ireland'. A simple idea that worked really well. Why wouldn't it, drawing on the wisdom and experience of people like Ken Whitaker, Paddy Lynch, Médhbh Conway and Tom Barrington? And Hilda Tweedy:

We need to develop a society where there are no hidden agendas, where there can be open debate on controversial issues such as divorce, contraception, abortion, euthanasia or homosexuality and where information is easily obtainable …

Brave and prophetic words, Hilda. We did spend a lot of time in the 1990s uncovering hidden agendas, debating those issues and searching for 'relative information'. It was and continues to be a painful process. We were opening up, all right. Each year seemed to bring a new can of worms, each one a more glutinous mess than the one before. Child abuse, bribery, planning scandals, tax evasion, naked greed, phone-tapping, political corruption — all leading to seemingly endless tribunals where the only winners are the lawyers. Where to begin?

For a start, how about two taoisigh resigning in the space of less than three years? Charles Haughey resigned in 1992 over allegations on the tapping of journalists' phones a decade earlier. In 1994, Albert Reynolds resigned over the Attorney-General's failure to process an RUC warrant for the extradition of paedophile priest Brendan Smyth. Worse was to follow for Haughey when the McCracken and Moriarty tribunals revealed a series of generous payments made to him and other politicians by businessman Ben Dunne ('Thanks a million, big fella!'). And ᵉane would enthral/appal (tick as appropriate) us on the *Late Late Show* with ᵉr liaison with C.J. Goodbye Charlie.

the Beef Tribunal into 'irregularities' in the administration of state credit ᵃ exports of beef to Iraq. A complicated minefield of intrigue that for the ᵗ Joe and Mary Citizen mystified. The Flood/Mahon tribunal will conᵗigate corruption in planning payments well into the twenty-first century. Tribunal exposed corruption and mismanagement among the Garda Donegal. The DIRT scandal, bogus accounts in the Cayman Islands, ᵃ Bank openly encouraging tax evasion. Oh, there was something rotten

all right, but the state wasn't Denmark. It was the dear little isle of saints and scholars. It wasn't so much that all of this corruption was happening in the 1990s, but that we were made aware of it then. An open society, indeed, Hilda.

The greatest casualty of all was TRUST. The more scandals that were revealed, the greater the erosion of trust in our leaders, be they temporal or moral. Yes, indeed — it could happen to a bishop. In 1992, it was revealed that Eamonn Casey, the extrovert Bishop of Galway, had had a liaison with an American woman, Annie Murphy, and that they had a son. Again, the nation sat transfixed as Annie Murphy told her story on the *Late Late Show*. Later, another cleric with a high media profile, Michael Cleary, would be similarly exposed. Truly, we were losing our innocence — fast. I remember Seán Ó Síocháin, one-time secretary of the GAA, telling me in a radio interview how, when he came to Dublin as a young man, he was amazed at how seldom city people doffed their caps to a priest in comparison with his native rural Cork. The cap-doffing days were truly gone now, Seán. Lost innocence and lost innocents. We learned through radio and television documentaries of the horrific abuse that had been inflicted on children in the institutional care of religious orders for the previous fifty years. Lost innocence, never to be recaptured. We were opening up all right, opening festering sores that would take a long, long time to heal.

But hey! It wasn't all gloom and doom. Didn't we have a booming economy? More of that presently. Let's talk sport — so often an antidote to the evils of the material world. Particularly amateur sport. Particularly GAA sport. One of the great (no, make that the greatest) sporting confrontations of modern times was the meeting of Meath and Dublin in the Leinster Senior Football Championship of 1991. The old rivals —

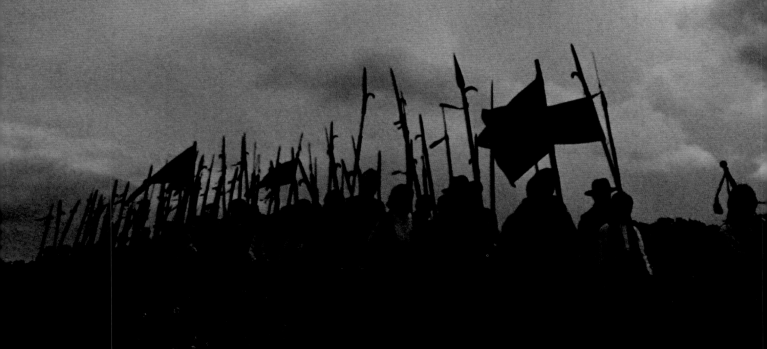

We are the boys of Wexford ... Pikemen commemorate the bicentenary of the 1798 Rebellion in County Wexford.
Page137:
Come dance with me in Ireland. President Mary Robinson among schoolchildren.

rednecks versus slickers. The battle raged over a period of five weeks, watched by an aggregate attendance of a quarter of a million people. A draw. A first replay with extra time. Still level. A second replay with extra time. Still level. It seemed as if they would never be prised apart. Of course it wasn't pretty. It was uncompromising, but for sheer passion, tension and total commitment, it was unsurpassable. No Hollywood scriptwriter would even dare to write such drama, in particular what happened in the third replay on Saturday 6 July. Meath six points down with twenty minutes left. Dublin miss a penalty but still lead by four points with five minutes left. And then (of course I'm biased) quite the most fantastic goal ever seen in Croke Park. Meath's O'Connell gathers on his own end line. To Lyons. To McCabe. To Harnan. To O'Rourke who is fouled. O'Rourke's free to Beggy. To Foley. To Gillic. To Dowd. To O'Rourke. Back to Dowd. To Foley. GOAL! (Foley! A half-back who never scored a goal for Meath before or since...) Croke Park erupts (watching at home on television — I am moving house — I erupt with a roar that sends our dog scuttling for his life and into hiding under a garden bush). Eleven passes and not one Dublin player touched the ball. But it's not over yet. Meath gain possession from the kick-out. Beggy kicks a point for the lead. Dublin miss a last-minute free and it's over. After five hours and forty minutes, Meath have won by a single point.

Unbelievable. And it was only the first round. It took Meath another five matches to

get to the All Ireland final where they lost narrowly to Down, but the Meath-Dublin saga defined the summer of '91. Moreover, it defined a new popularity for Gaelic games, a popularity which burgeoned over the decade and was reflected in the total rebuilding of Croke Park into the unrivalled stadium it is today. In hurling, there were glory days for Clare who came out of the wilderness in 1995 and returned to the lime-light in 1997. And for Wexford, under manager Liam Griffin, there was glory in 1996. When one of the players was asked what their manager's philosophy was, he replied, 'Next ball … !' So you've just missed an open goal, or your opponent has just scored a goal? So what? Next ball! Next ball! What a wonderful philosophy for LIFE! And wasn't it Liam Griffin who described hurling as the 'Riverdance of games'? Now where did he get that expression?

We were winning Eurovision with painful regularity but something extraordinary happened during the interval of Eurovision '94. Bill Whelan conceived a fusion of music and Irish dancing with the explosive talents of Michael Flatley and Jean Butler, and Riverdance was born. The ecstatic response of the audience signified that this was no mere interval-filler. This was Irish dancing at a new level — passionate, fiery, sexy — and when the interval act was expanded to *Riverdance*, the show, it literally conquered the world.

When it came to the economy, we were world leaders also in the 1990s. A combina-tion of low inflation, a well-educated workforce, low interest rates fuelling a credit/mortgage explosion, increased investment and expanding government revenues led to sustained high-level economic growth in the middle of the decade. A cumulative growth of over 50 per cent between 1993 and 1998 matched that achieved in the first forty years of independence and surpassed that of the previously dominant Asian 'tiger' economies. The Celtic Tiger was born. It was an extraordinary achievement. A gener-ation before, we had been exporting our labour force on emigrant ships and planes. Even a decade before, we were struggling with huge unemployment and oppressive interest rates and inflation. But now there was wealth, spectacular wealth for some. Money was cheaply available. Invest in property. You never had it so good. The Dublin skyline was symbolic of the age, dominated by giant, towering cranes. Shopping centres, super-pubs, a profusion of coffee and wine bars, chic restaurants, trendy bou-tiques and vast department stores. Shop till you drop. Spend, spend, spend. We were the new confident Irish, the envy of neighbours near and far. There was a spring in our step. It wasn't just an economic miracle. It was a psychological transformation. For gen-erations, centuries, we had considered ourselves inferior to our oppressors. Also-rans. But now, we were strutting our stuff on the world stage — proud, self-confident tigers. And yet … And yet … Were we forgetting something?

That question was growing at the back of some people's minds, at least. It was

gnawing particularly at Fr Harry Bohan's mind. One of the most dynamic figures in Irish society, Fr Harry had for years been involved in promoting rural housing and community development. He welcomed the Celtic Tiger and its attendant prosperity but found it:

> *… ironic that current development is being increasingly shaped by the remote large corporation, with economic criteria the main — and sometimes the sole — arbiter of change. People, place, roots and — dare we say — soul, are secondary considerations in the decision-making process and often totally ignored in our headlong rush to economic nirvana. So, are we forgetting something?*

Ever a man of action, Fr Harry and his organisation, Rural Resource Development, convened a conference in Ennis in 1998 to examine our society in the new millennium. The theme was Harry's question that would not go away — 'Are We Forgetting Something?' It was an important, ground-breaking conference that asked crucial questions about our society, and it has continued and grown organically since then under

The poet from Mossbawn in County Derry — who, thirty years earlier, observing his father digging, had decided that he would 'dig' with 'the squat pen that rests between finger and thumb' — was finally rewarded in 1995 with the ultimate acclaim, the Nobel Prize for Literature. A fitting reward for an extraordinary corpus of work. Others would also keep the humanities flag flying. Roddy Doyle won the 1993 Booker Prize for *Paddy Clarke, Ha Ha Ha* and Frank McCourt's darkly humorous account of his Limerick childhood, *Angela's Ashes*, won the Pulitzer Prize in 1997. The poetry of Paul Muldoon, Eavan Boland, Michael Longley, Paul Durcan, Nuala Ní Dhomhnaill, Brendan Kennelly and others helped enrich that 'awareness of the facts of economic life' that Patrick Lynch had asked for. There was also encouragement in the rise of exciting new dramatists such as Marina Carr, Martin McDonagh, Billy Roche, Enda Walshe and Sebastian Barry. One of the most memorable theatrical experiences of the 1990s for me was the privilege of seeing the late and lamented Donal McCann's tour de force in Barry's *Steward of Christendom*.

All of those emerging dramatists were, of course, aspiring to the heights attained by the master, Brian Friel, whose poignant and exhilarating *Dancing at Lughnasa* captivated audiences throughout the 1990s.

LEFT: Michelle de Bruin swimming for Ireland at the 1996 Atlanta Olympics. She won an unprecedented three gold medals and one bronze.
RIGHT: Silver Sonia. After the heartbreak of the Atlanta Olympics, Sonia O'Sullivan bounced back at Sydney 2000 to take the silver medal in the 5,000 metres.
BELOW: Drimnagh gold. Michael Carruth proudly displays his boxing gold medal at the Barcelona Olympics 1992.

They were dancing in the streets of Drimnagh in 1992 when boxer Michael Carruth won a gold medal at the Barcelona Olympics. Four years later, they were dancing in the streets of Rathcoole when local swimmer Michelle Smith de Bruin won gold at the Atlanta Olympics - not once, not twice but three times. Michelle was subsequently found to have tampered with a urine sample while being tested for drugs at her Kilkenny home, and suddenly the gloss faded from the gold. She still has the medals, of course. For Sonia O'Sullivan, our premier athlete of the 1990s, Atlanta was a disaster. Rows over her running gear, failing to finish, tears instead of the expected medals, but Sonia bounced back with a silver medal in the Sydney 2000 Olympics.

As if in response to Hilda Tweedy's call for 'open debate on such issues as divorce and abortion', we had two referenda. We said yes (just) to divorce and, following an acrimonious debate on abortion (prompted by the 'X Case' when a 14-year-old rape victim was prevented from travelling to Britain for an abortion), we said no, by a two to one majority. We said hello to John Bruton as Taoiseach in 1994 but bade farewell to his coalition two years later when Fianna Fáil's new kid on the block, Bertie Ahern, became Taoiseach.

BELOW: Tour d'Irlande. In 1998, the Tour de France started in Ireland. Here competitors cross King's River in Hollywood, County Wicklow.
RIGHT: Ireland v Albania, final score 2–0. Niall Quinn heading the ball towards goal, 26 May 1992.

During Bruton's brief term in office, however, building on the earlier work of Albert Reynolds, things had begun to move on the Northern Ireland question. Bruton and the British premier John Major agreed on a framework document towards a lasting settlement and, even though the IRA renewed its campaign of violence in 1996 with bombs in London and Manchester, a new player entered the scene. A player who would have an extraordinarily influential role in the ultimate Peace Process.

Senator George Mitchell had come to Northern Ireland as President Clinton's special adviser and, in June 1996, he was invited to chair the peace negotiations which had eventually got under way. It seemed an impossible task – to find a way through division, mistrust and ultimate hatred that had been deepened and embedded over centuries. The political leaders had chosen their chairman well, however. George Mitchell is patient, resolute and wise in the extreme and this island owes him an incalculable debt. After two years of painstaking negotiation, a peace agreement was reached on Good Friday 1998, and overwhelmingly endorsed on both sides of the border in May 1998. A new Assembly was elected and although that Assembly has been in stop-start mode latterly, George Mitchell has no doubt but that the Agreement will endure.

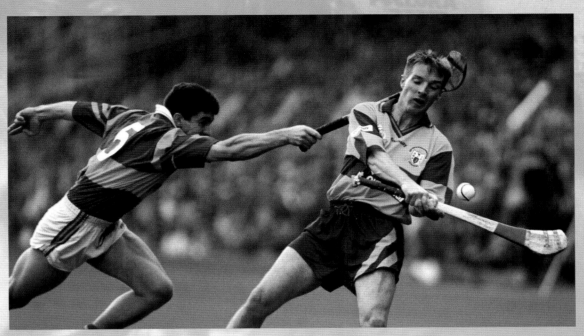

LEFT: Dún Laoghaire yachtsmen training for the Olympics, 1992.

ABOVE: Clare v Tipperary, All Ireland Hurling Final 1997. Final score Clare 0–20, Tipperary 2–13. Clare wing forward Jamesie O'Connor getting a shot away under pressure from Liam Sheedy of Tipperary.

BELOW: Close finish, Leopardstown 1994.

Pages146–147:
Water hazard. The Kildare hunt reflects on its next move.

It will endure because it is fair and balanced; it reflects a true, principled compromise and most importantly, commits all the participants to the disarmament of all paramilitary organisations and to the use of exclusively democratic and peaceful means to resolve their political differences.

Senator Mitchell spoke those words in University College Cork, where he delivered the 1998 'Open Mind' Guest Lecture. I was deeply privileged that he agreed to give that lecture. For two hours, he enthralled and entertained a packed audience. It was a very special evening.

Reconciliation, genuine reconciliation will be much harder to come by (than political stability) and will take much longer ... I think it will eventually be the children of Northern Ireland who will bring about genuine reconciliation — children who have not lived through the difficult times of the past, when each new grievance brought a renewal of hatred and a thirst for revenge ...

The Good Friday Agreement was for Senator Mitchell the realisation of a dream that had sustained him through 'three and a half of the most difficult years of my life'. It was equally the realisation of a dream for the people of this island, particularly those who had been caught in the vortex of thirty violent years in Northern Ireland. The Good Friday Agreement was easily the most significant event of the 1990s for them, for all of us. And Senator Mitchell wasn't finished dreaming. He concluded his lecture thus:

My dream now is that, in a few years, I will take my young son and return to Northern Ireland. We will tour that beautiful country until, on one rainy afternoon, we'll go to visit the new Northern Ireland Assembly. That won't be difficult, because almost every afternoon is a rainy afternoon! And there we will sit in the Visitors' Gallery of the Assembly and watch the delegates debate the ordinary issues of life in a democratic country — healthcare, education, agriculture, fisheries, tourism. There will be no talk of war, for the war will have long been over. There will be no talk of peace, for peace will be taken for granted. On that day, the day in which peace is taken for granted in Northern Ireland, I will be truly fulfilled.

That day of fulfilment has not yet arrived. Senator Mitchell warned that there would be setbacks. And there were — none more horrific than that of the Omagh bombing, three months after the Good Friday Agreement. The profoundly evil work of dissident IRA members took the lives of twenty-nine people and two unborn babies and made Omagh synonymous with suffering. Much courage and resolve would be needed by political leaders before George Mitchell's dream would be realised. The resolve of two of them was duly recognised in 1998 when John Hume and David Trimble shared the Nobel Peace Prize.

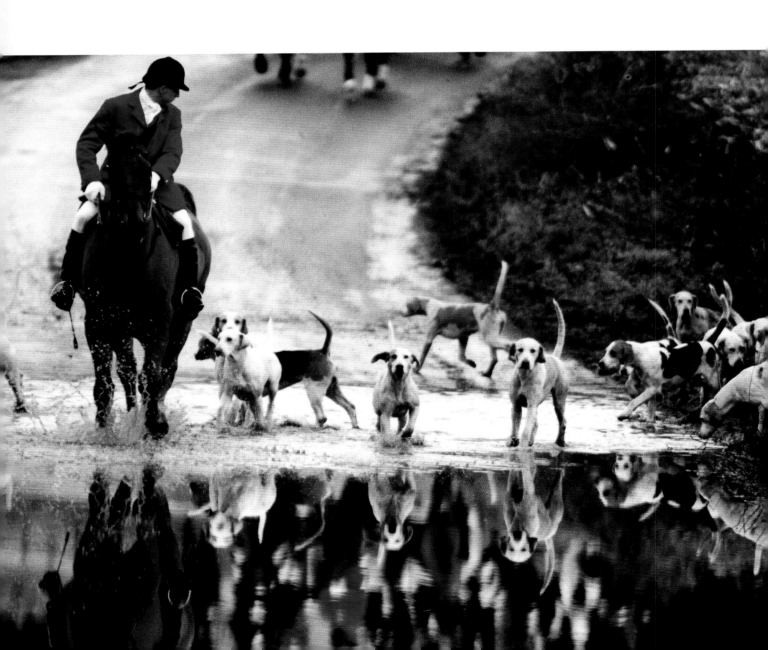

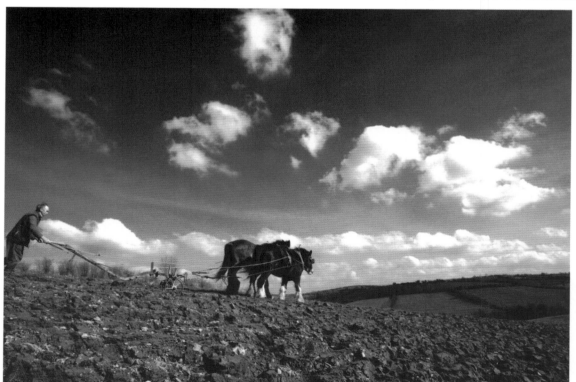

LEFT TOP AND BOTTOM: Preserving a tradition. Benny Mone from Clontibret, County Monaghan, uses traditional methods in ploughing, sowing and reaping on his farm.
BELOW: Hillman. Wicklow sheep-farmer Mick Cullen.

A fairytale — or what began as a fairytale — ended tragically in a Parisian underpass in 1997 when Princess Diana and her lover Dodi Fayed were killed in a traffic accident. It was the final cruel twist in the life of the shy young nursery-teacher who would be queen. A fairytale marriage to the heir to the British throne went horribly off the rails and the media devoured every moment of it. Diana's death and the manner of it — pursued to the end by paparazzi — caused a huge outpouring of grief in Britain and exposed the Royal Family as a rather cold and aloof lot.

Here in Ireland, we bade farewell to one of our own icons. It wasn't a tragedy but simply the end of a career. Gay Byrne finally bowed out of our living rooms and kitchens when he brought the curtain down on forty years of radio and television broadcasting. Both his radio show and the long-running *Late Late Show* on television had opened up many a debate and got us talking to ourselves about ourselves.

ABOVE: Benny Mone, traditional farmer from Clontibret, Co. Monaghan.
RIGHT TOP: Eclipse of the sun, recorded in Wicklow, 11 August 1999.
RIGHT BOTTOM: Heavenly body. The comet *Hyakutake* captured on a one-hour exposure, 27 March 1996.

There was controversy, there was laughter, there was tragedy — all happening in a little box in the corner of the Irish living room. We may not always have got definitive answers to who we were and where we were going but at least it got us talking. As the song said, 'it started on the Late Late Show ...'

The end of the 1990s was also the end of a century and of a millennium. Time to celebrate. Fireworks. Parties. And time to reflect. We had come a long way in the century, never mind the millennium. Independence. Self-reliance. Self-discovery. Growth. Prosperity. Part of a new Europe. Memorable achievement in the artistic and sporting fields.

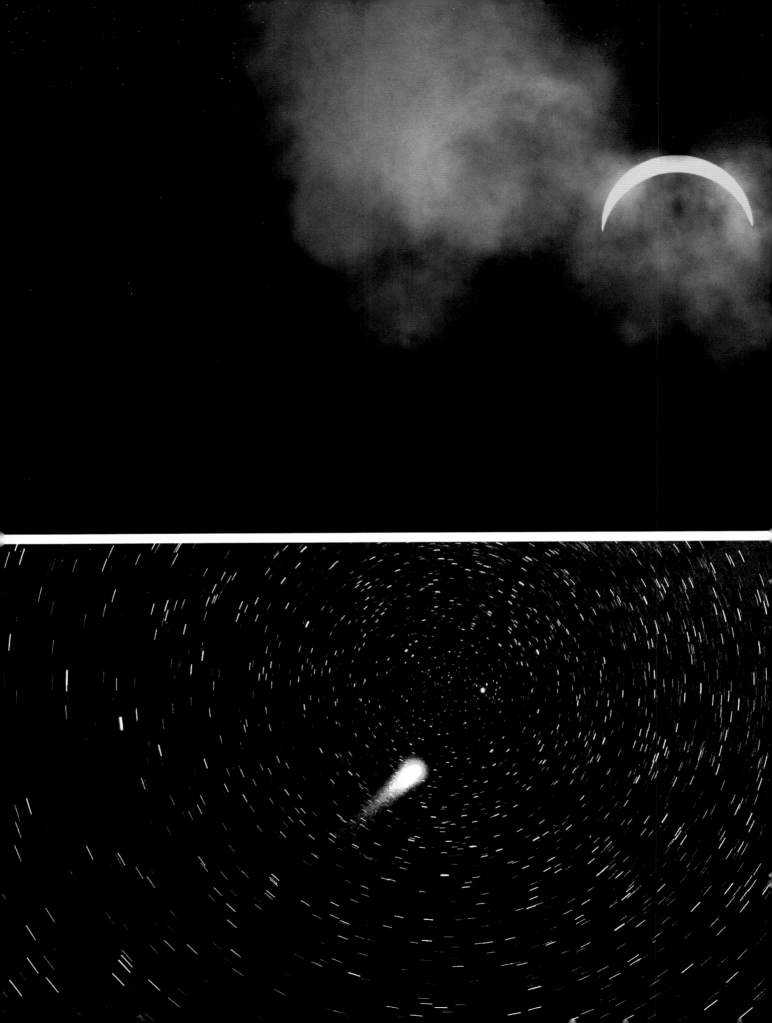

The changing face of Irish fashion. Dublin fashion shoot.

A proud people. A contented people. Yes, but ... We still had inequity. In real life, as opposed to television, there isn't 'one for everyone in the audience'. We still had injustice. We experienced pain as the darker sides of our society and our psyche were exposed. Above all, we experienced a loss of trust as scandal after scandal was exposed at all levels of society. We were hurt. We were angry. It would take time for wounds to heal, for trust to be won back. Truly, we had come a long way but truly also, in the words of an electoral slogan of the new millennium, there was 'a lot done, a lot more to do'.

The New Millennium

And so we slid into a new century, a new millennium. The twenty-first century. Not so long ago, it was the stuff of science fiction. Space odysseys. Would we holiday on the moon? Now it was here and only some of the fiction had become fact. The main fact was that our world was anything but one world. Parts of Planet Earth were experiencing living conditions that our ancestors had to contend with one and two centuries ago. Abject poverty, disease, famine, illiteracy, misery. Our civilisation has made extraordinary advances in knowledge and technology but our brothers and sisters scratch a parched soil for food that would keep them alive for another day. We reach for the stars and beyond, but in parts of this little star, a child dies needlessly every two seconds ...

One of the reasons the publishers of this book gave for asking me to write this commentary was that I had lived through the period in focus ... Thank you, indeed, Michael O'Brien, for that vote of confidence. The Ireland of my childhood is an Ireland my own children could not imagine, would not understand. And yet it is a childhood that I cherish. There was little in the way of privilege or prosperity but I felt sheltered and loved. The family unit was strong; the sense of community was palpable. As I said earlier, it took a village to raise a child. But it is easy to idealise and romanticise. They were austere and authoritarian times. In the case of both home and Rome, you did not step out of line ... In the village of Ballivor, we had neither running water nor sewerage. Electricity arrived with the 1950s. Very few homes had a telephone — I earned many a sixpence by delivering telegrams. Most children finished their education at primary school. The Quinn children were lucky to avail of secondary education in boarding school only through the extreme sacrifice of their hardworking and poorly-paid parents. Dublin was only thirty miles away but if you visited it more than twice a year (a trip to Croke Park in summer and a Christmas shopping trip when your mother sold the turkeys), you were surely in the privileged class. And all of this was a mere fifty years ago.

Mary McAleese, a president of grace and warmth.

Labuntur anni, as my Latin teacher, Brother Gabriel, reminded us in boarding school. The years glide by. My children live in comfort today. The world is their oyster. They have worked and backpacked in Australia and America. They have seen more of the world than I will ever see. They are free. They are independent. They pay little heed to Rome (sadly!) but they care a lot about home. They have instant communication through their mobile phones. They are at ease with technology. They have grown up in a world of accelerating change and uncertainty — a far cry from the very certain world that I experienced. They are open and confident. I am proud of

them, not for their 'achievements', but because they are good, caring and loving people. That, as Gordon Wilson said, is the bottom line.

As a state, we are, after all, in relative youth. Four score years might be the span of a man's life but in the life of a state it is a short span. In 1998, to mark the state's seventy-fifth anniversary, I invited into a radio studio two men who were more than adequately equipped to review the state's progress – Ken Whitaker and Paddy Lynch. Now in their eighties, they had – as it were – grown up with the state. In the 1950s, they were dynamic young civil servants whose thinking would ultimately help shape and direct the growth of a fledgling state. Personally, I bow to no one in my admiration of them and I have been privileged to know them.

Both men recognised that the state was 'coming of age' after seventy-five years, having begun life as a weak and fragile

economic entity. Here are some snatches from a very important conversation:

WHITAKER: We have seen in our time a very distinct move from isolation to openness in every aspect of the economy — and indeed culturally as well.

LYNCH: There is an air of self-confidence about. Of course we still have an underclass and unemployment and that has to be tackled. But if you consider 1998 as the zenith of economic achievement, then 1956 was surely the nadir. There was economic stagnation, politics seemed to have failed. We seemed to have a collective death wish …

WHITAKER: Moving from protectionism to free trade was the landmark achievement. Technology and trade opened us up. We became part of an interdependent world …

LEFT: Woman of three centuries. Aran-born Bridget Dirrane died in 2003, aged 109 years.
BELOW: The changing faces of Ireland. Grafton Street, Dublin.

Bertie Ahern TD. Entering Dáil Éireann as part of the Fianna Fáil landslide of 1977, he was Minister for Labour in 1982 and Minister for Finance 1991–94. He became leader of Fianna Fáil in 1994 and Taoiseach in 1997. His coalition government oversaw the Celtic Tiger and the Peace Process in Northern Ireland. Re-elected Taoiseach in 2002, Ahern led Ireland's distinguished presidency of the EU in 2004.

LYNCH: That was highlighted in 1973 when we were hit by the oil crisis. But 1973 was also a watershed year because of our joining the European Community — something which has transformed us economically, intellectually and socially …

WHITAKER: Although it's approaching payback time now, when we will no longer be beneficiaries but will have to contribute to the European Budget!

LYNCH: I think it is important that we acknowledge the role of politicians in the state's growth - people like McSharry, Dukes and Haughey in Finance and Hillery and O'Malley in Education …

WHITAKER: I regard education as the main key to our progress. The numbers attending third-level education have doubled to one hundred thousand in the last ten years alone. There is inequity there of course, but we have made extraordinary strides. The average family today is three to four times better off than their counterparts in 1922. The death rate has halved and life expectancy is up by fifteen years …

LYNCH: That for me is the landmark achievement — the elimination of the squalor of the inner cities and of rural Ireland and the general improvement in living standards …

WHITAKER: Don't forget too the extraordinary switch from rural to urban living. In 1922, for every one person working in industry, there were eleven working on the land. Today, eighty per cent of the workforce is engaged in industry and services.

('The Open Mind')

All changed then. We have peace in Northern Ireland after thirty years of horror. A fragile peace, but a welcome one. And a peace to be worked at. The historian J. C. Beckett has noted that 'the real partition of Ireland is not on the map but in the minds of the people. And we live in a fragile world. On 11 September 2001, my elation at holding my first grandchild in my arms for the first time was tempered by the awful events that were unfolding on live television from New York and Washington. What kind of world would this little mite in my hands grow into? Sadly, she would never know her maternal grandmother. Two months before she was born, Olive Quinn, the beautiful woman who had bewitched me thirty-five years earlier in her black leather coat, had been taken from us rather suddenly. All changed indeed.

The hatred and division of mankind apart, our world is fragile for other reasons. It is reckoned that 20 per cent of the world's population (and that would include a 'developed' nation like ours) uses two-thirds of the planet's resources and generates three-quarters of its pollution. Our resources are finite. Our capacity to pollute seems to be infinite. Do we really care about what we are doing to the environment? What kind of Ireland will we hand on to our grandchildren? And … if they follow our example …?

I retired from RTÉ Radio in 2002 after a career of twenty-seven years, mostly in 'educational' programmes — in the broadest sense of the word. It was a wonderful career

of privilege rather than work. I was merely a conduit for ideas and experiences, while also having the benefit of a personal education from the minds of Charles Handy, Ken Whitaker, Seamus Heaney, Frank Mitchell, Harry Bohan, Patrick Lynch, Jim Deeny, Mike Cooley and many, many more. RTÉ has a proud record in public-service broadcasting, particularly in radio. While world trends indicate that such broadcasting is under threat, I would argue that it was never more needed. The dumbing down of television in the form of increasingly inane 'reality' and game shows is a cause of concern. In 1970, Lelia Doolan (now a valued neighbour of mine) and the late Jack Dowling, both then television producers with RTÉ, wrote a controversial book — *Sit Down and Be Counted*. They challenged the direction the fledgling national television was taking.

> *Nobody for a moment was saying that you could run programmes for nothing. Never. But the question was whether we should try and think of another means, another method, another model for television than the one we had. We felt that the local area was important as the focus and the locus from which the work would come, rather than that it should all come from one centre and then be diffused throughout the countryside. Why does television have to be show business? Could it not also be a two-way event in part?*

('My Education')

Those are still challenging questions in the twenty-first century. The advent and success of TG4 has been important and welcome in the interim. Thirty years later, Professor Joe Lee was asking similar questions at that seminal Céifín Conference in Ennis, when he called for the 'operationalising (of) all the fashionable, but frequently fraudulent, rhetoric of inclusiveness and pluralism'. This would mean, he said:

> *... equality of access to the public media — equality by place and by age as well as by gender, instead of confinement to the charmed circles of a couple of square miles, and to the privileged age and gender groups ... There is a long struggle ahead — a twenty-year march through the institutions — if this drift is to be reversed and Ireland is to become a genuinely inclusive, pluralistic society — words that trip so lightly off our lips and which are so often belied by our behaviour and to whose achievement a balanced sense of place can make an important contribution.*

('Are We Forgetting Something?')

Liz O'Donnell TD, member of the Progressive Democrats.

A sense of place. Ken Whitaker noted that the greatest social change in his lifetime had been the switch from a largely rural to a largely urban society. Can you have a sense of place if you commute daily to the capital from Longford or Carlow or Gorey? Urbanisation brings with it the threats of isolation and anonymity. The closely knit extended family has become atomised. The rise of the 'Me Generation' promoted individualism and selfishness. Greed was good, the Gordon Geckos of this world pronounced. We are accused of being a rip-off society. The disaffected, the alienated and the marginalised have been sucked into crime and the scourge of drug-abuse. Fractures and fissures run through society at all levels as the authority of family, church and state

ABOVE: Suits in the Centre. Economic conversation in the Irish Financial Services Centre, Dublin.
RIGHT: Brian Cowen TD. The Offaly-born member of Fianna Fáil has held crucial portfolios in government, notably Health and Foreign Affairs.

wanes. At times, it does indeed seem that the centre cannot hold. A long way indeed from De Valera's dream.

My great mentor, Charles Handy, argues that what we need is 'proper selfishness'. We will only really find ourselves when we lose ourselves in something beyond ourselves — be it our love for someone, our pursuit of a cause or vocation, or our commitment to a group or an institution.

> *Untrammelled individualism corrupts a nation. It leads to an emphasis on rights, with no regard to duties or responsibilities. It breeds distrust and jealousy and lots of layers. If we can leave families when we feel like it, are free to ignore or insult our neighbours, treat organisations as stepping stones on a personal trip and only make friends with people who will be useful contacts, to be discarded when no longer needed, we will erode that 'social capital' which more and more people are recognising as the bedrock of a successful and prosperous society.*

('The Hungry Spirit')

We need community. At the very time that the concept is under strain — and in some instances has already collapsed — we need to reclaim it and possibly redefine it. One of the most remarkable transformations in our society in the past decade has been its enrichment by the infusion of immigrants from all over the globe. It is reckoned that there are now 166 nationalities represented in our society. What possibilities that offers us if, as Joe Lee says, we are genuinely inclusive ... When we speak of community, due credit must be paid to the Gaelic Athletic Association which has long flourished as a

162

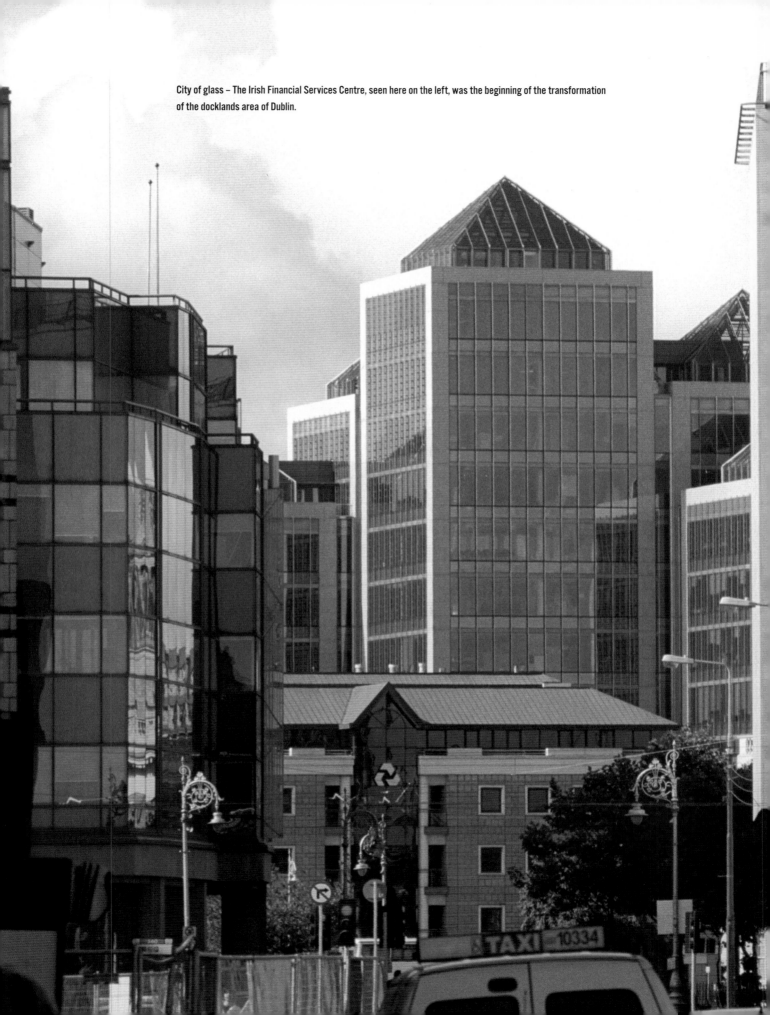

City of glass – The Irish Financial Services Centre, seen here on the left, was the beginning of the transformation of the docklands area of Dublin.

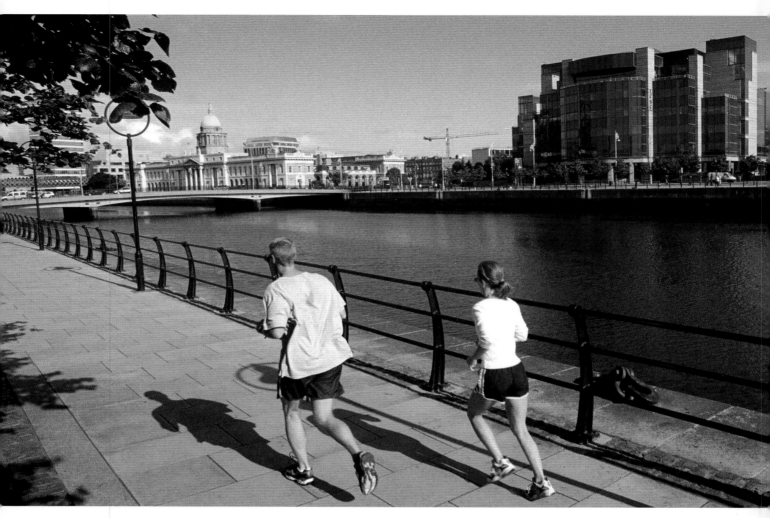

ABOVE: Anna Livia Plurabelle – the River Liffey has witnessed great change over the past fifty years – revitalised docklands, new bridges, new people, new pastimes.
RIGHT: How's it goin' with yourself? Multicultural Ireland, 2004.

fulcrum of 'social capital' through the loyalty of its members and fans. 'Come on, de Rebels ... Caltra, kings of Ireland ... You'll never beat the Royal ...' It surely lifts the heart to see school hurling and football team-sheets include exotic names from Nigeria or Eastern Europe ...

As with all challenges, reclaiming or redefining community is easier said than done. Imaginative, creative approaches will be needed but, as another mentor of mine, the late Jim Deeny, pointed out:

> *Once you start community development it brings out the creativity in people. Our education system smothers creativity, but we need to bring it out in people ...*

('My Education')

Jim Deeny was Chief Medical Advisor to the Department of Health in the 1940s — one of the many dynamic and devoted public servants of that time, but when he retired to farming in County Wexford and became involved in community development, he truly found himself.

The ordinary people of Tagoat have educated me greatly. I meet more brains in the course of the day than you would in a university and an awful lot of them never had a chance in life. A lot of them are content and wise and they have taught me goodness …

('My Education')

That, to me, is a profoundly true and encouraging statement. It underscores the untapped value of community in education. It has been said that schooling represents only 20 per cent of a young person's life. Who and what will fill the other 80 per cent? I write these closing pages in August 2004. The Leaving Certificate results are just out. The media are full of analysis and observation on the cut-throat competition for points to gain entry to third-level education. We live in a culture that promotes competition, almost from pre-school days, when our focus should be on collaboration and co-operation. Ours is a culture that extols 'success' and highlights 'failure'. (The Olympic Games are also in progress. 'Phelps fails to win eight gold medals,' the headline screams. He actually won six gold medals and two bronze but his 'failure' is highlighted…)

There is much public debate and hand-wringing about failure and falling standards in the science subjects. Maybe we should focus more on education towards imagination and creativity and curiosity. It is imaginative, curious, young people who will save us, rather than the high-scoring performers — people who will ask the right questions rather than know the right answers. I say this as a product of the 'don't ask … whatever

New faces, new colours.
There are now 166 nationalities represented in Irish society ...
BOTTOM LEFT AND RIGHT: Where are you now? Technology rules in a
time-conscious era.

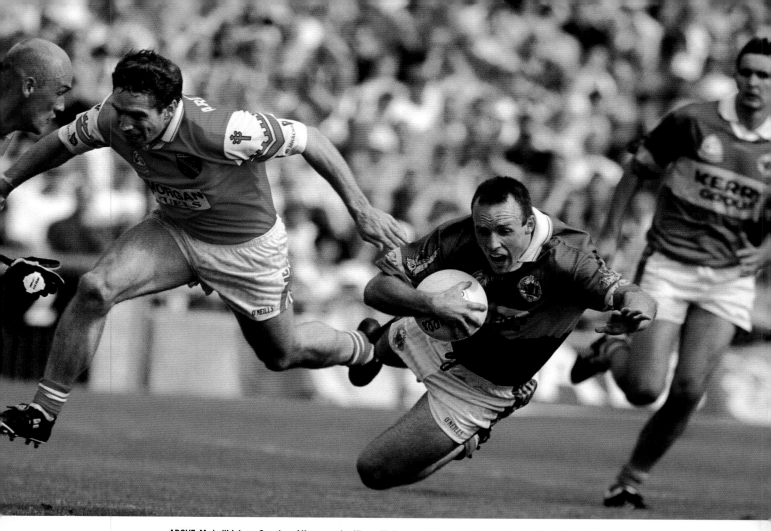

ABOVE: My ball! Johnny Crowley of Kerry evades Kieran McGeeney of Armagh, All Ireland Football Semi-final, 2000.
OPPOSITE TOP LEFT: Many say he was the greatest of them all. The great Kerry midfielder, Mick O'Connell.
OPPOSITE TOP RIGHT: Mick O'Dwyer, long-serving Gaelic football manager. He has managed Kerry, Kildare and Laois county teams and has won several All Ireland football medals for Kerry.
OPPOSITE BOTTOM: Racing with the tide. Geesala Strand races, Belmullet, County Mayo, 2001.

you say, say nothing ... toe the line ... curiosity killed the cat ... sit down and be counted' era. But maybe it's time I got off the soapbox ...

Although I have no roots there, I love to go back to my native village of Ballivor. All is changed there too. The house I was born in is derelict, the site soon to be redeveloped for 'townhouses'. Fields and gardens I played in are now housing estates, largely the homes of daily commuters to Dublin. Where Whelehan's butcher's shop once stood (whose door was our 'goals' in street football), there now stands a takeaway. The Protestant church, whose door we were warned (under pain of sin!) never to darken, is now a computer training centre. The old school is a health centre. The most striking building in the village is the Credit Union. And the garda barracks, where my father locked up 'drunk and disorderlies' overnight (and sprouted his seed potatoes too) is now a tyre centre. All changed. Oh goodnight Ballivor ...

But I still love to walk down that main street. The ghosts of the past greet me. There's Harry Garry, tying up a parcel with a smile and a joke in Mc Laughlin's shop. Father Cuffe is dragging me in from minding cattle on fair day to serve Mass. You cannot

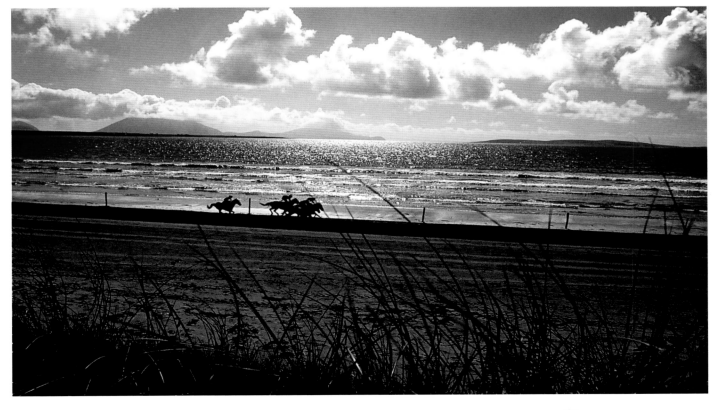

A far-from-everyday occurrence: Venus crossing the sun, 8 June 2004, seen from Ballinastockan, County Wicklow. The next transit of Venus will occur on 11 December 2117.

Pages 174–175:
LEFT: 'O Westport in the light of Asia Minor ...' Poet Paul Durcan.
RIGHT: Harcourt Street lines reborn. Luas trams negotiate the graceful sweep of Harcourt Street, Dublin 2004.

serve God and Mammon … I ogle at a toy truck in Eugene Leddy's shop window but am fearful of his eccentric moods. The blacksmith, Bill Kelly, comes up to our house for dinner and then beats me at draughts – again! But one day … one day I will beat him. My mother is in the back kitchen, singing 'Charmaine' while she hard–boils eggs and nettles for the turkey chicks. My father pauses from planting potatoes in the barrack garden to show me how to blow my runny nose. Press your thumb on one nostril and blow hard on the other one! 'Sure you're only throwing away what the gentleman puts in his pocket…' And from within the still-standing Sherrock's Garage, Jimmy Cagney cries out, 'Made it, Ma! Top of the world.'

A sense of place. My great hero of today, Sean Boylan, manager of the Meath football team (since I was a boy, or so it seems) likes to quote the Apache saying – 'We are what we are, but we are what we were too'. One of the great debates of our time concerns whether, amid all our prosperity and progress, we as a society (as an economy?) should align ourselves with Boston or Berlin. Irrespective of that outcome, we should never lose sight of Ballyfermot or Ballydehob either. Or, for that matter, Ballivor.

John Quinn
3.02 p.m.
Thursday 19 August 2004

New O'Connell Street; New Dublin; New Ireland:
The tricolour flies over the birthplace of revolution,
Jim Larkin appeals for the downtrodden and,
between them, the Spire soars majestically
into the blue.

JIM
LARKIN

1874-1947